PAINTING BIRDS STEP BY STEP

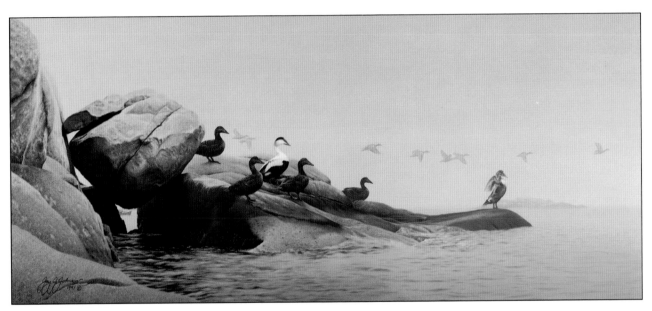

EIDER ON THE MUSCLE RIDGE
(Common eider)
Jay J. Johnson, Oil, 19" × 42"

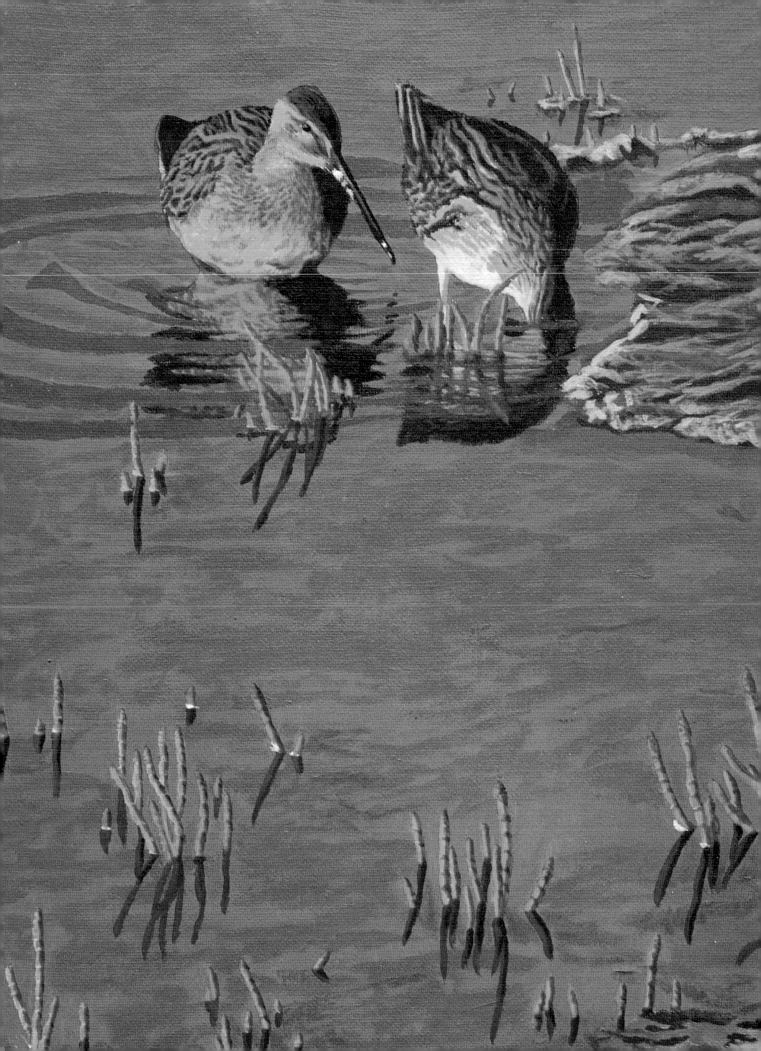

PAINTING
BIRDS
STEP BY STEP

BART RULON

N

NORTH LIGHT BOOKS
CINCINNATI, OHIO

DOWITCHERS FEEDING
AND PICKLEWEED
Bart Rulon, Acrylic, 18"×24"

ABOUT THE AUTHOR

Born in 1968, Bart Rulon now lives and works on beautiful Whidbey Island in Washington State's Puget Sound. His career started with a bachelor's degree from the University of Kentucky in a self-made major titled Scientific Illustration. After graduating with honors he immediately started working as a full-time artist focusing on wildlife and landscape subjects and specializing in birds. Since then his works have been exhibited in many of the finest exhibitions, museums and galleries displaying wildlife and landscape art in the United States, Canada and abroad. His paintings have been included regularly in the prestigious exhibitions and national tours hosted by the Leigh Yawkey Woodson Art Museum including the "Birds in Art," "Wildlife: The Artist's View," and "Natural Wonders" exhibits. He is a member of the Society of Animal Artists where he has been included in each of their grand annual "Art and the Animal" exhibitions since becoming a member. His work has also been regularly juried into the Arts for the Parks top 100 exhibitions and national tours for several years, and in 1994 he won their "Bird Art Award." In 1995, Rulon's paintings were included in a sale at Christie's famous auction house in London. His paintings and sketches of birds are included in the permanent collection of the Leigh Yawkey Woodson Art Museum.

Bart's work has been featured on the cover and interior of many issues of *Bird Watcher's Digest*. Recently, he has been working on several bird field guide illustrations for *A Guide to the Birds of the West Indies*, to be published by Princeton Press, and the Wildlife Federation field guide *All the Birds of North America*, to be published by Simon & Schuster. His artwork and techniques are also featured in *Wildlife Painting Step by Step* by Patrick Seslar (North Light Books, 1994).

Rulon's primary interest is in experiencing his subject firsthand in the wild. "The fieldwork is by far the most important and enjoyable part of being an artist for me, and it has taken me to some of the most exciting places in the world. I focus on painting subjects that I have seen in the wild rather than trying to paint those that I've never seen, no matter how obscure they may be."

Hobbies that occupy Bart's time when he's not painting include fishing, kayaking, soccer, basketball, weight lifting, bird-watching, camping and beach volleyball, to name a few.

Library of Congress Cataloging-in-Publication Data

Rulon, Bart.
 Painting Birds Step by Step / Bart Rulon.
 p. cm.
 Includes index.
 ISBN 0-89134-632-5 (alk. paper)
 1. Birds in art. 2. Painting—Technique. I. Title.
ND1380.R78 1996
751.4—dc20 95-35786
 CIP

Edited by Rachel Wolf and Pamela Seyring
Designed by Sandy Conopeotis Kent
Cover illustration by Terry Isaac

METRIC CONVERSION CHART		
TO CONVERT	**TO**	**MULTIPLY BY**
Inches	Centimeters	2.54
Centimeters	Inches	0.4
Feet	Centimeters	30.5
Centimeters	Feet	0.03
Yards	Meters	0.9
Meters	Yards	1.1
Sq. Inches	Sq. Centimeters	6.45
Sq. Centimeters	Sq. Inches	0.16
Sq. Feet	Sq. Meters	0.09
Sq. Meters	Sq. Feet	10.8
Sq. Yards	Sq. Meters	0.8
Sq. Meters	Sq. Yards	1.2
Pounds	Kilograms	0.45
Kilograms	Pounds	2.2
Ounces	Grams	28.4
Grams	Ounces	0.04

I DEDICATE THIS BOOK TO MY MOM, DAD AND BROTHER.
YOU MEAN THE WORLD TO ME.

ACKNOWLEDGMENTS

First and foremost I want to thank the fantastic artists that contributed their time, effort and artwork to help make this book possible. I have admired the paintings of each and every one of you, and it is a great honor for me to have your work and expertise included in this book. After all your hard work I can only hope to have done your artwork justice here.

Secondly, I want to thank my family: my Dad, Art; Mom, Althea; brother, Barron; aunt, Joyce Rulon; and uncle, Dr. Tom Rulon. You each helped me in different ways,

with advice on subjects involving the book and checking over my writing; but, most importantly, you all gave me enough encouragement to help survive the long hours looking at a computer screen. It has been very important to me that you have all always believed in what I do as an artist.

In addition I would like to thank my friends John and Linda Kipling for their encouragement and for letting me borrow their computer. I would not have been able to do it without your help. Thanks to Michelle Thomsen for allowing me to

borrow her printer for my final draft, and Bill Lytollis and Ashley McCormack for letting me borrow their printer in the very early stages of this project.

Last but not least, I want to thank my editor, Rachel Wolf. You are certainly a very skilled editor, and I feel lucky to have had your guidance and advice. You were a delight to work with on this book project, and I hope we have a chance to work together again sometime. Believe it or not, I really did enjoy working on this book and all the challenges it brought with it.

TABLE OF CONTENTS

FIELDWORK
The Heart of It All

5

Foreword

The tremendous diversity of birds—their color, form, size, behaviors and habitats—make them fantastic subjects for artwork. Remarkably, for all the paintings that have been done of birds, we still have only seen but a sampling of the range of ideas that can come from using birds as subjects, ranging all the way from hyperrealism to impressionism.

This book by Bart Rulon showcases the rich diversity of birds, and the art of some of the best bird painters of today, while passing on important techniques and advice to those who want to carry on the tradition of painting birds. Over the years, the quality of bird art improves because new artists learn from their predecessors and have tools available to them that earlier artists did not. The book starts with the time-tested importance of fieldwork, which has been emphasized by masters. Whether it is sketching, painting, photographing or just watching birds, fieldwork provides the direct inspiration, knowledge and experience needed to portray birds with an artist's passion.

However, this is not just a book for artists. It is also ideal for anyone interested in birds and nature. Bird-watching is becoming more popular and this book would complement the library of any avid birder. Artists and bird-watchers are very much alike; they are both primarily interested in the visual beauty of a bird and its environment. The bird-watcher enjoys watching birds. A bird painter takes this pleasure one step further by recreating those natural moments for others to see.

Bird sketching and painting can make a better bird-watcher out of anyone. The visual accuracy needed to sketch birds in the field makes a bird-watcher more skilled at noticing the specific characteristics that distinguish one species from another. Sketching can be a fantastic way to identify more birds with better accuracy, and can be especially useful when traveling in unfamiliar places. This book teaches you how to do it.

Here is the work of a young artist trying to perpetuate an interest in birds both through his art and that of other accomplished artists. This striking collection of drawings, paintings and demonstrations is something that anyone would enjoy perusing again and again. The text will help developing artists focus on the most important aspects of painting birds. There are no fool-proof formulas, but this book provides new ways to improve your paintings. Becoming a better bird painter simply means determination.

—*Roger Tory Peterson*
April 10, 1995

BECARD, FLYCATCHERS
Roger Tory Peterson

Introduction

As artists, we have many tools to recreate a scene—memory, photographs, sketches and study skins, for example. We also have another big advantage. We can create something that we have not actually seen, an impossibility for photographers.

However, it is essential to draw from your own experiences. Don't cheat yourself out of the most enjoyable part of painting birds—fieldwork. Most of us choose to paint birds because we are fascinated by them. Watching a bird behaving naturally is uniquely inspiring. Painting is the best way to recreate these experiences and to communicate a sense of "being there" to others.

Watching a bird inspires a child-like curiosity in me. I can't help wondering what that bird has been doing and where it has been. This curiosity creates an endless variety of visual possibilities of what a bird has been up to. By spending time outside looking for and watching birds and their habitats, I continually gain knowledge I can draw upon to create scenes that would likely happen in real life. Curiosity about wildlife and the outdoors sparked my interest in painting birds, and now the discipline of being an artist creates even more curiosity about places and birds I would not have experienced otherwise.

Creating artwork out of your own experiences will make your art unique. If we all draw our total inspiration from the field, a diversity of ideas will come forth. We all see things differently. Several artists who go into the same patch of woods for inspiration produce very different paintings. If you want your work to stand out and be unique you must rely as much as possible on your own experiences.

Fieldwork is the most important part of painting birds. Whether your time is spent sketching, painting, photographing or just observing, it will all pay off in future paintings. Relying on your own work in the field has three main advantages: (1) a better understanding of your subjects, (2) increased exposure to good painting ideas, and (3) less danger of repeating ideas.

For an artist, no amount of reading or looking at published photographs can replace the understanding gained by watching a bird firsthand. Books and photographs can be very helpful, but they will not be enough to help you create substantial art. You must understand how a bird moves, behaves and interacts with its habitat to portray it with credibility. If you witness a certain behavior, you can be confident in portraying it, and you can avoid the uncertainty (which will always somehow be communicated in your painting) about trying to portray a behavior you have knowledge about but haven't seen.

The same goes for painting birds in correct habitats. If you *see* a bird in a certain habitat you don't have to wonder about whether or not it is likely to be found there because you have witnessed it. Many people lose interest in paintings that portray a bird incorrectly. It is best not to hinder the quality of your work with faulty depictions.

The more time you spend outside researching your subjects, the more good ideas you are going to be able to see and use for paintings. I have always thought that as painters we are only limited by how much we can see. There are an unlimited number of great scenes and birds to paint, and the best way to actually spark an idea about them is to go out and see it for yourself.

Photos in books or magazines can be impressive, but to copy from them is only cheating your creativity. Beginning artists tend to copy photographs from magazines for part or all of their paintings. I would like to discourage this for several reasons. First of all, the act of being an artist involves orginality, and this is lost if you copy an idea from someone else. Secondly, copying published photographs can break copyright laws and even result in possible litigation. Lastly, and most importantly, copying someone's photographs limits your growth as a painter because it shifts the important picture-planning decisions to someone else.

If you are a beginner, I strongly recommend starting out on the right foot by gathering your own references. From the beginning this will force you to think about the initial steps in planning a painting. I also recommend against trying to paint birds for which you can't gather your own references. There are so many birds out there to paint; you will ultimately create better paintings if you concentrate on the ones you can study firsthand.

BLUE-CROWNED MANAKIN IN ECUADOR
Bart Rulon, Watercolor, 9" × 12"
Collection of the Leigh Yawkey Woodson Art Museum

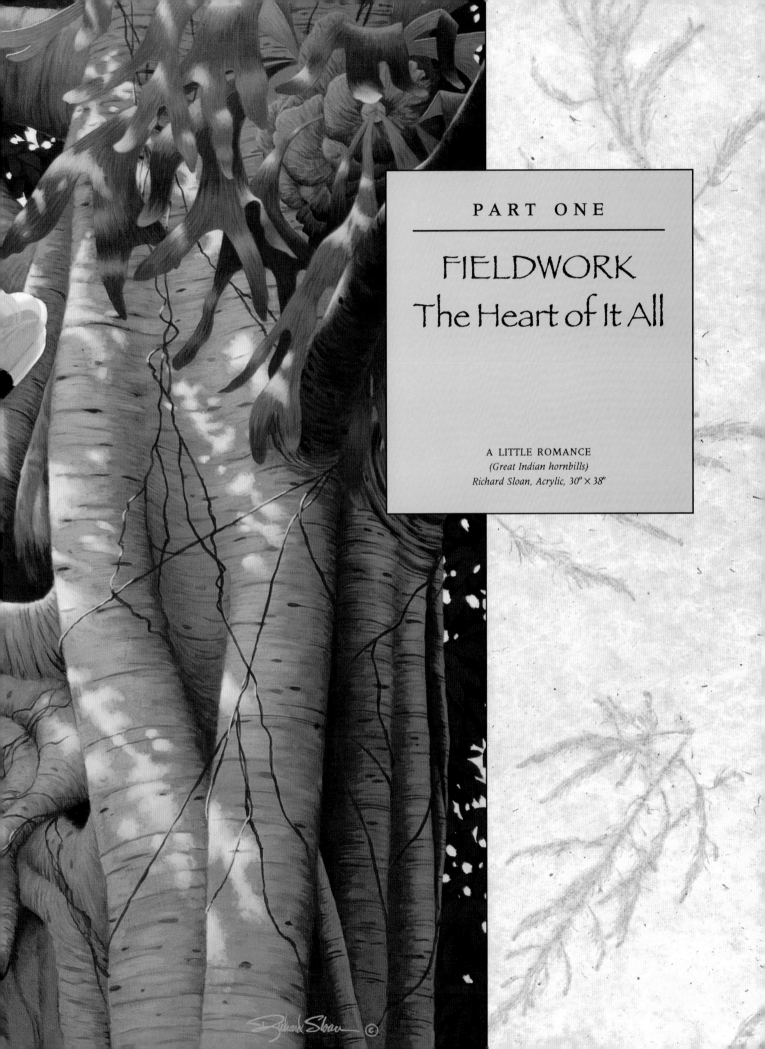

PART ONE

FIELDWORK
The Heart of It All

A LITTLE ROMANCE
(Great Indian hornbills)
Richard Sloan, Acrylic, 30" × 38"

The Importance of Field Sketching

With the abundance of photography equipment available today, you might think that sketching is a thing of the past, but it's not. Sketching will always be one of the most useful practices in gathering references for paintings.

WHEN PHOTOGRAPHY IS IMPOSSIBLE

There are a multitude of situations where you will be able to see birds but cannot take adequate photographs of them. You might see something unsuspected happen in a split second, or witness a bird through binoculars or a spotting scope. In these cases, sketching will be the best recording tool. In some cases, you have to rely totally on memory, but it's always more desirable to go back home with an idea sketched on paper than to return empty-handed.

Recording Unique Gestures
This can be achieved with the aid of a spotting scope, which magnified this kingfisher. The resulting sketches have given me important visual and behavioral information that I've used for paintings and will draw upon for many years to come.

Sketching From Memory
One foggy evening I was watching common goldeneyes scattered along the water's edge, and then at dusk they all congregated and swam as a tight group away from shore. After walking home, I sketched the group, relying on the memory of how they were spaced and how the males were displaying to the females by throwing their heads back.

GAINING KNOWLEDGE

Sketching will ultimately teach more than snapping a picture, because it requires understanding lots of information. The visual knowledge you amass about a bird by drawing it over and over again will give you flexibility for planning paintings and will help you catch any anatomical errors that might come up in the planning stages.

IMMEDIATE RESULTS

Another advantage of sketching is that it provides you with immediate references to work from. If you want to work on a painting idea immediately after returning from the field, you can if you have sketches. In contrast, relying totally on photographs forces you to wait until the roll of film is finished or until the film is developed. Sometimes, working right away, while the idea is fresh, is the best way to paint.

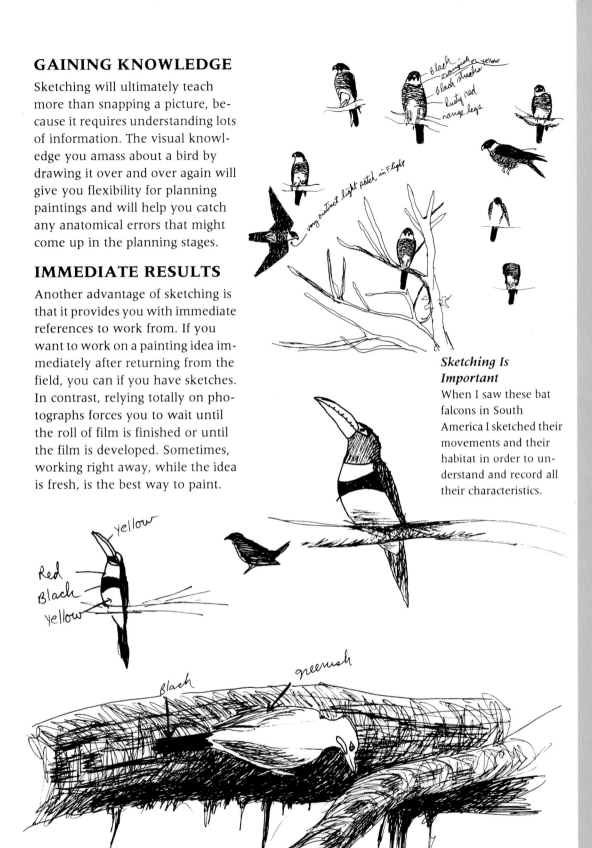

Sketching Is Important

When I saw these bat falcons in South America I sketched their movements and their habitat in order to understand and record all their characteristics.

A Matter of Seconds

It was necessary to capture the correct posture and proportions of this woodpecker quickly, as well as make notes on the bird's colors. Since the bird was seen in South America, I recorded and learned as much as possible, because I might never see another one again. Along with the memory of the experience, this sketch would have been enough to start a painting.

How to Sketch From Life

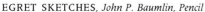

Trying to draw a bird that not only won't stand still, but is moving rather fast, can be very intimidating. One of the biggest obstacles to overcome in sketching is the fear of failure. To overcome this fear, think of your sketchbooks as a private library. You don't have to show the results of your sketches to anyone. This keeps your attention on drawing what you see as quickly as possible, rather than tediously making a drawing to try to impress someone.

Sketches can be used to understand what red-breasted mergansers look like immediately after surfacing from a dive, and how their heads look as they turn.

OBSERVING

Before sketching, observe the bird without drawing. Pay attention to anatomy, contour, gesture and detail. Note how the bird's parts relate to each other. Record shapes, sizes, angles, proportions, and placement of head, beak, body, tail and legs. A sketch may often concentrate on just one of these areas, but purposes can be combined.

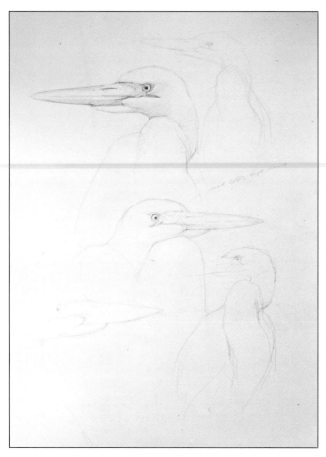

EGRET SKETCHES, *John P. Baumlin, Pencil*

SAW-WHET OWL SKETCHES, *John P. Baumlin, Pencil, 14" × 11"*

Sketching for Gesture
In these sketches you can see clearly how the shape and angles of the neck change when the egret moves its head.

Sketching for Details
These sketches record feather details, especially around the owl's head.

Loose Gesture Sketches

Gesture involves the position of a bird as it moves. Sketches should be very loose and quick, with few details. Sketch each different pose as long as it is held. Ask yourself the same kinds of questions as when observing anatomy, beginning with major relationships.

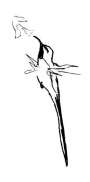

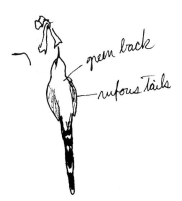

green back

rufous tails

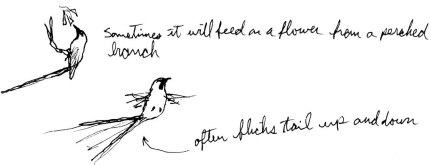

Sometimes it will feed on a flower from a perched branch

often flicks tail up and down

The most noticeable thing about this black-tailed trainbearer (a tropical hummingbird) was its extremely long tail, which appeared to be a few inches longer than its body. The bill was fairly short and skinny, and the legs were tucked into the lower belly feathers so that only the feet were visible. *Below,* I've noted the kinds of things I look for when doing a gesture sketch.

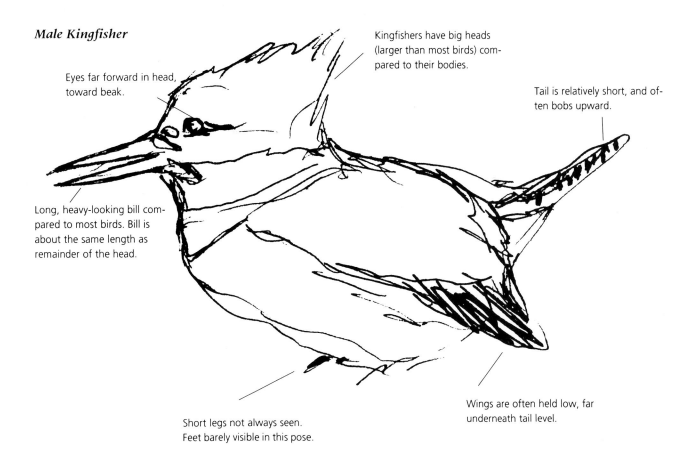

Male Kingfisher

Eyes far forward in head, toward beak.

Kingfishers have big heads (larger than most birds) compared to their bodies.

Tail is relatively short, and often bobs upward.

Long, heavy-looking bill compared to most birds. Bill is about the same length as remainder of the head.

Short legs not always seen. Feet barely visible in this pose.

Wings are often held low, far underneath tail level.

Quick Contour Sketches

Doing many quick sketches rendering only the general outlines of a subject, without worrying about preciseness, not only helps you warm up, but also builds confidence in going directly from sight to sketchpad. Speed is the key. Just draw quickly, without looking down at your sketch. Trust your hand to capture the gesture.

The contour sketch is valuable for capturing movement because it is quick and provides instant lines, approximating what you saw in a loose manner and providing a general rendering of what happened.

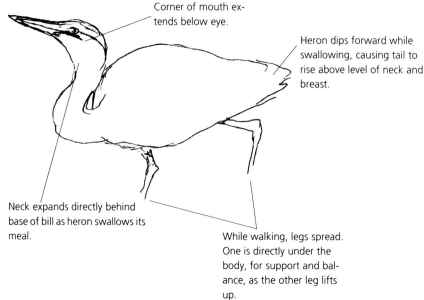

Corner of mouth extends below eye.

Heron dips forward while swallowing, causing tail to rise above level of neck and breast.

Neck expands directly behind base of bill as heron swallows its meal.

While walking, legs spread. One is directly under the body, for support and balance, as the other leg lifts up.

Legs
Pay special attention to the length and movements of the legs when sketching long-legged wading birds such as this great blue heron.

Unique Markings
Characteristic marks under tail, as well as on breast, head and flanks are very important in depicting the male green-winged teal.

Great Blue Heron

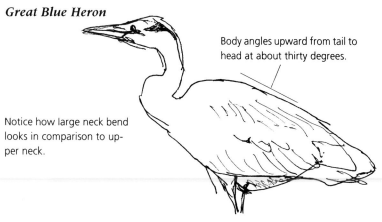

Body angles upward from tail to head at about thirty degrees.

Notice how large neck bend looks in comparison to upper neck.

Green-Winged Teal

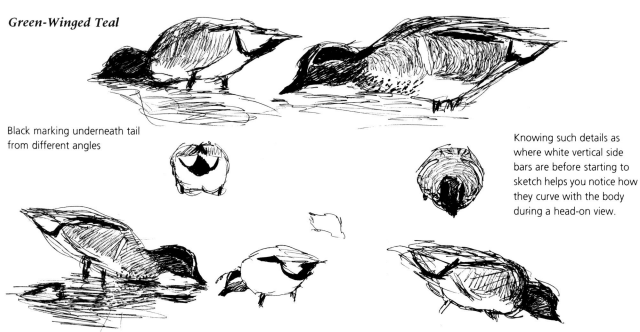

Black marking underneath tail from different angles

Knowing such details as where white vertical side bars are before starting to sketch helps you notice how they curve with the body during a head-on view.

Sketching for Detail

Details are smaller, more particular parts of the bird. If your purpose is recording minute feather patterns, gesture may be incompelete in order to concentrate on one area.

NOTE FEATHER MARKINGS

Feather markings are an important means of identification. Note major plumage first, then look at smaller details. This teaches visual facts for accurate rendering. Some questions to ask about distinguishing characteristics include:

- Does the bird have wing bars?
- Is the breast streaked?
- Are there any markings on the tail?

> **Tips From the Pros**
>
> "Do not draw anything that you did not observe, even if it leaves the sketch unfinished. If you don't have enough time to observe all of the details, then don't put them in, because this would be asking for mistakes. A very simple sketch that is correct is better than a very detailed sketch with questionable accuracy."
> —Bart Rulon

Male Kingfisher
These are the kinds of feather notations I would make on this kingfisher sketch.

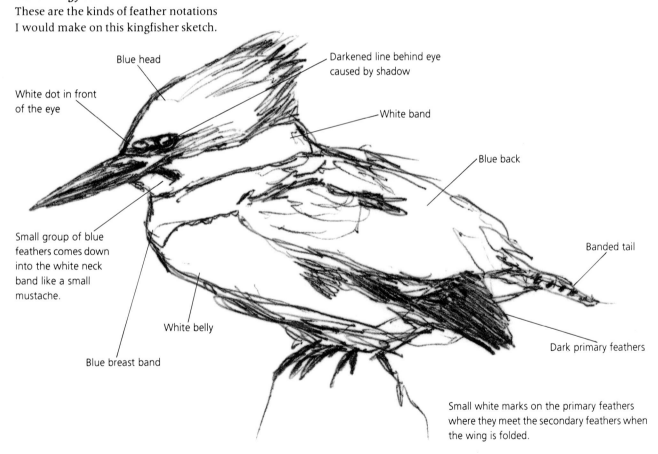

White dot in front of the eye

Blue head

Darkened line behind eye caused by shadow

White band

Blue back

Small group of blue feathers comes down into the white neck band like a small mustache.

White belly

Blue breast band

Banded tail

Dark primary feathers

Small white marks on the primary feathers where they meet the secondary feathers when the wing is folded.

Capturing Action

Here's a valuable and simple trick to help freeze action for drawing fast-moving birds. It works best when the bird is silhouetted against a light background, like the sky. Simply watch the bird, then close your eyes to freeze the action. It makes an image "burn" on your retina long enough to record the basics. The effect is similar to staring at a brightly lit window for a while from inside a dark room. If you close your eyes the image is "burned" into your retina for a period of time depending on the amount of contrast and how long you stare at the object. This only freezes the outline or silhouette of a subject, and doesn't allow you to see any details. After sketching the contour, have another look or rely on memory to fill in any details you want in the drawing.

Sketching Repeated Poses
A technique to use after you have had an opportunity to recognize positions that a bird frequently returns to is to draw as much as you can while the bird stays in one pose, then leave the sketch unfinished to start a new pose on the same page when the bird moves. When the bird eventually returns to the first pose, return to the first sketch.

If the Bird Is Moving
Start with quick contour drawings to establish position. All three of these sketches of a greater scaup (at left) began this way, without looking down at the paper to check. The angles of breast and head were most important. After the contour sketch, make corrections and rough in details.

Yellow-Rumped Caciques
These birds often sing with heads pointed downward and back feathers ruffed up. The contour drawings at right established the lowered head and wings, and the raised back feathers; they also show where markings and the eye should be placed, as well as the opened bill.

Sketching With Pen and Ink
I have chosen to do most of my sketches in pen and ink for two major reasons:
1. It's impossible to erase mistakes. Corrections can be made with heavier lines, but you can look back at mistakes and learn.
2. Ink doesn't smudge or need a fixative.

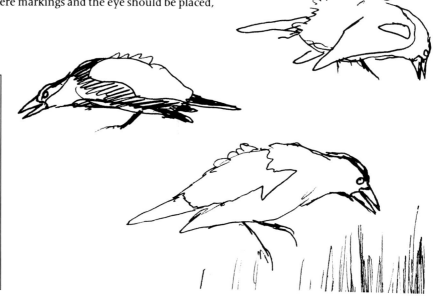

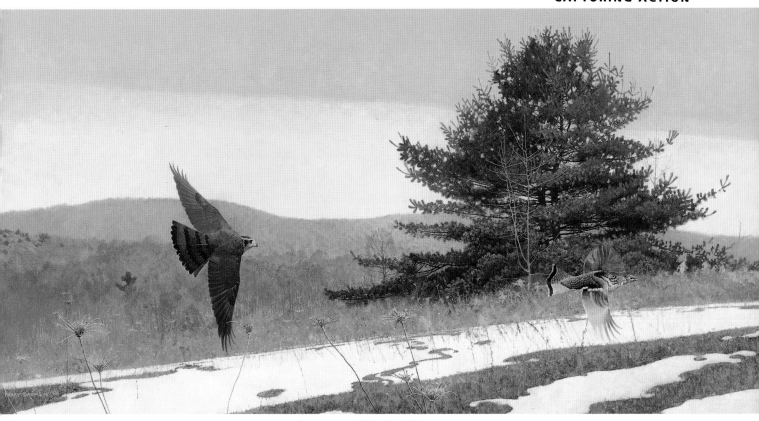

HAWK AND GROUSE
John P. Baumlin,, Acrylic on board, 18" × 36"

Action Is an Effective Theme
See how well the connection of the ruffed grouse and goshawk engages your attention.

Freeze the Action
The tufted puffins at right provide a perfect example of closing your eyes to freeze the action. Flying off their nests and down to my eye level, their black color against the light sky and ocean created ideal silhouettes. The resulting sketches provided me with good information, especially on how the feet are held in different stages of flight. These quick contours show how important the feet are for steering and braking before a landing.

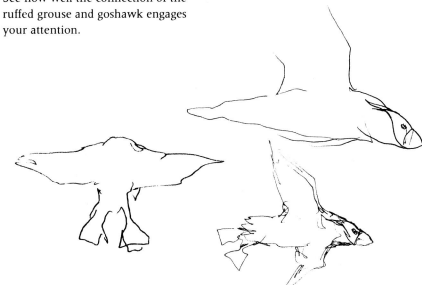

Three Consecutive Sketches
This lettered aracari was easy to draw by closing my eyes to "freeze" each stage. Results show how the breast moves down as the wings are lifted, and how it moves up as the wings are thrust downward. The last sketch shows how the aracari will momentarily close its wings, resulting in a dip in its flight pattern, similar to the way woodpeckers fly.

Make Notes
After finishing the sketch, make written notes about bird behaviors, wind direction (if it's blowing feathers out of place) or anything relevant, like information about the surrounding habitat.

Sketching and Sighting Equipment

Sketching can be made easier with the aid of binoculars, spotting scopes and telephoto lenses.

BINOCULARS

Purchase as high quality optics as you possibly can. The magnification you need will depend on the types of birds you sketch most. Lower magnification binoculars, or the naked eye, are the best choices for small birds moving quickly at close range. For birds that will be seen from a distance, such as water birds, I would recommend a spotting scope (see below) or high-magnification binoculars that can be mounted on a tripod. Trying to hold heavy binoculars and sketch at the same time is very difficult.

SPOTTING SCOPE

Spotting scopes are useful for seeing birds at a distance. They come with either zoom magnification or interchangeable eyepieces. Clarity and brightness at different powers are the most important qualities in a spotting scope.

Clarity

Zoom scopes are most convenient for quickly changing magnification, but frequently lose their clarity at higher powers, whereas interchangeables typically do not lose as much clarity.

Brightness

Another quality to look for is how bright an image the spotting scope creates. This is very important when sketching in low light. The brighter the image, the more details you will be able to see.

Keep Both Eyes Open

Spotting scopes have only one viewing lens (compared with the two found on binoculars) but it is recommended that you keep both eyes open. To help make this easier, take a piece of cardboard measuring about 4″ × 9″ and cut a hole in the middle of it to fit over the ocular lens of your spotting scope. When mounted, it will help you concentrate on the image you are seeing through the lens because one eye will see only the blank mat board, while the other focuses on the more detailed image.

Get a Bird Feeder
Sketching birds at feeders helps if you are just beginning to sketch from life, because you can arrange it so that the birds are close enough to see without the aid of binoculars. Once you have built some confidence in sketching birds with your naked eye, it may be easier to make the transition to sketching through binoculars. Leave a sketchbook ready to go next to a window facing the bird feeder, so that you can sketch at any time.

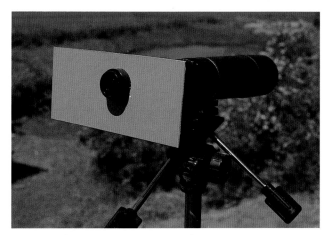

Keep Both Eyes Open
A piece of cardboard or mat board (about 4″ × 9″) with a hole cut in it to fit over the ocular lens on your spotting scope can help you concentrate on the image through the lens while keeping both eyes open.

TELEPHOTO LENS

Using the telephoto lens for sighting and sketching, you can quickly take a picture at any time. While the camera is mounted on a tripod, you can sketch with one hand and keep the other on the remote trigger or cable release, pushing it whenever you want a picture. It doesn't even interrupt the process of sketching. This technique solves the problem of deciding whether to sketch or photograph a situation— you can do both simultaneously.

SKETCHPAD SUPPORT

It is helpful to have something to support your sketchpad while drawing. This is not a problem when sketching from a seated position, but for the times when you are standing, the following tools can help.

Tripod

I have built a small wooden drawing platform that screws into the tripod quickly and holds a sketchpad, freeing my hands for drawing and following the bird with binoculars. The platform is screwed onto a quick-release plate so that it can be quickly attached or detached.

Wearable Board

Another simple tool comes in handy when you need more mobility. Cut a light piece of hardboard slightly bigger than your sketchpad. Cut two holes in the top two corners, and two more holes on the bottom edge, centered about six or eight inches apart. Secure a soft rope around your waist, tied to the bottom edge holes. Tie a strap or soft rope to the top corner holes as a neck strap. This portable sketching support is especially valuable when sketching for long periods of time standing up, or with subjects that are moving around a lot and must be followed.

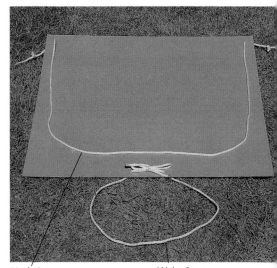

Neck Strap Waist Strap

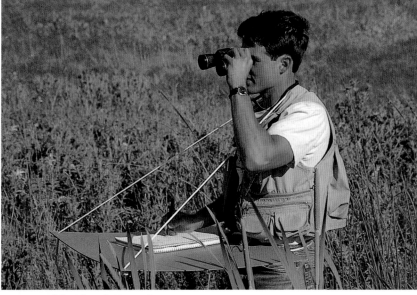

A Wearable Sketch Board
This device frees one hand for holding binoculars while sketching. It is supported at the neck and waist with simple knots. Sketching is thus much easier in semi-open areas, and this device is great for sketch trips to the zoo.

15

Basic Photo Equipment

Photography is a tremendous aid to painting birds. Photographs instantly record details and actions in a fraction of the time it would take to sketch them. The more references you can gather about birds, the better your chances of making accurate and original paintings.

CAMERAS AND LENSES

Thirty-five millimeter is no doubt the most suitable camera format to use for photographing birds. It offers the most versatility, including multitudes of lenses, accessories and films to choose from at reasonable prices.

MOTOR DRIVE

Motor drives are indispensable for bird photography. They automatically advance the film after each photograph is taken, giving you the capability of taking several photographs per second to capture more gestures of a bird as it moves. It is very difficult, for example, to shoot a single picture of a bird taking flight and have it turn out to be a good one. Several shots using the motor drive will afford a better chance of capturing the wingbeats and positions that will be good for a painting.

TELEPHOTO LENSES

Telephoto lenses will make your bird photography more productive for distant shots. A 400mm lens is a good overall choice.

In addition to having a long telephoto lens, it is also a good idea to have a zoom telephoto lens that ranges from 100mm to 200mm or 300mm, for larger birds for which you don't need as much magnification. Zooms are great for enabling you to change picture format quickly.

TELECONVERTERS

Teleconverters are available in all major camera brands and are normally available in 1.4×, 2× and 3× powers. To find out how much power a teleconverter adds to your lens, simply multiply the teleconverter power by the length of your lens. For example, a 2× converter added to a 400mm lens gives you an 800mm lens. Unfortunately, teleconverters reduce the amount of light reaching the film and they reduce the quality of your photographs. For these two reasons, I would not recommend buying any teleconverter more powerful than 1.4×.

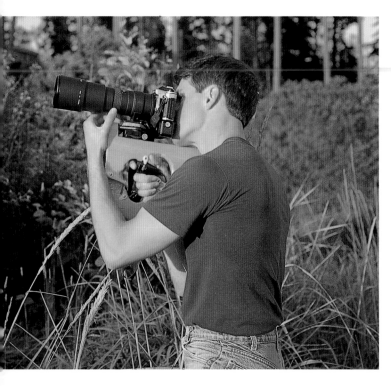

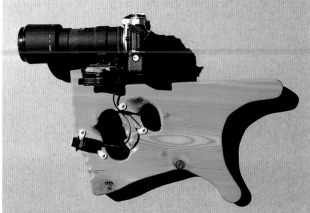

Shoulder Support
When mobility is a priority, a monopod (not shown) or a shoulder support are good alternatives to a tripod because they are quicker to set up and less difficult to carry. Many monopods are sold on the market that are suitable. The shoulder support that I use is designed like a gunstock that rests on one shoulder. The mechanism for tripping the camera shutter is mounted like a gun trigger. Both the monopod and gunstock are also particularly good for photographing birds in flight. Camera gunstocks are available through some camera supply catalogs, but they are quite easy to make yourself with the help of a bandsaw and a few simple tools.

Camera Supports

The larger the telephoto lens, the more sensitive it will be to camera shake, and the more difficult it will be to hand-hold your camera. Tripods, monopods, window mounts and shoulder supports are tools that can be used to help steady a camera and lens for better pictures.

TRIPODS

A tripod is definitely the steadiest support one can use for telephoto lenses. Tripods have many uses, and help to produce sharp photographs.

Look for a tripod that comes close to your eye level without extending the center column. Also look for a tripod that is capable of supporting a camera very close to ground level. In many situations, it is best to get as low as possible to take pictures, especially when birds are nervous about your presence.

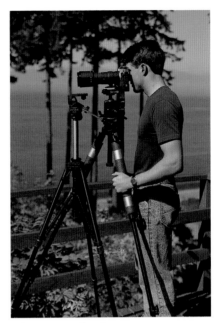

Choose a Tripod
Get one that comes to eye level without raising the center post. The tripod standing alone on the left needs the center column raised. This results in a less stable support, and takes more time to set up.

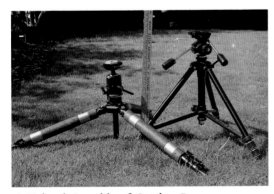

A Tripod Capable of Getting Low
This will give you even more versatility. Often an approach that is low to the ground will not bother birds, while walking toward them will. Most tripods capable of ''getting low'' usually do not have supports that run from the center column to each leg.

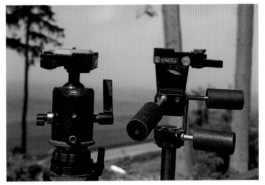

Ball Head and Pan-And-Tilt Head
The ball head (left) is preferable for wildlife photography because it is easier to follow moving subjects with it. One lever locks and unlocks the ball head, but the pan-and-tilt head (right) has three screw lock handles that need adjusting every time you want to lock or unlock the camera from a certain position.

Using Blinds

The most reliable way to get close to birds is to be concealed in a blind, most often made out of fabric, wood, or natural vegetation which has a camouflage effect so that it does not draw attention.

The most exciting thing about using a blind is that it lets birds approach to within a few feet of you without even knowing you are there. This allows close-up observation of a bird's natural behaviors without disturbing them, and without the aid of binoculars. A blind also allows someone without a long telephoto lens to get close enough to take adequate photographs of a bird.

CAR AS BLIND

Many birds are used to seeing cars. The birds see cars going past them all day long, and soon regard vehicles as nonthreatening. Some wildlife may not be alarmed by a car passing by, but might be alarmed when a car stops nearby. The best way to approach a bird when driving a car is very cautiously and slowly. A fast-moving car that stops suddenly is much more alarming than a slow-moving car that stops gradually. Sometimes it pays to stop for a few minutes at a time between advances, to ease a bird's nervousness. Once the car is within a good range to take photographs, turn off the engine to avoid camera shake. Steady your camera with a bean bag or window mount.

BOAT AS BLIND

Using a canoe or kayak is effective for approaching shorebirds, seabirds, gulls, and many other water birds. Many ducks are still difficult to approach. Quite often, diving birds will unexpectedly come to the surface a few feet away and provide excellent opportunities to photograph. Approach birds with a canoe or kayak slowly, and avoid quick movements. Try to let the boat glide closer without using the paddles, because any movements could cause alarm.

USING A BLIND WITH DECOYS

Using a blind with decoys can be a very effective way to attract ducks, geese and shorebirds within camera range. Using decoys is probably one of the best ways to get photographs of birds flying and landing, because the birds will fly close by to take a look, and sometimes land among the decoys.

CAMOUFLAGE BLIND

An effective blind is made out of camouflage fabric draped over you and your camera gear. This blind works so well that I have frequently had birds land right on my head!

In many cases it's most effective to set up or get into a blind when the birds are not present. This will often require setting up before sunrise. Once a blind is set up, some birds may require a period of time before they feel at ease around the strange new structure, while others will be fooled immediately. I have found that acceptance varies between different species, and even between individuals within a species. Birds that are very familiar with the location where a blind is set up will be most suspicious of the strange object. For such careful birds, set up a blind and leave it unattended for a few hours or a few days. Start to use it when the birds display no fear of the blind.

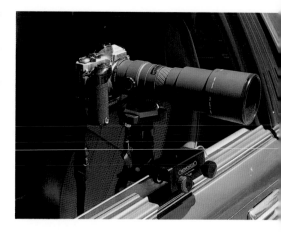

A Window Mount
This will help steady the camera while taking photographs from your car.

Backyard Blinds
For backyard feeders, you can build a simple blind that can be left out all the time and is ready for use whenever you like. A house also makes a good blind, as long as there is a window that can be opened to photograph through.

Make Your Own Fabric Blind

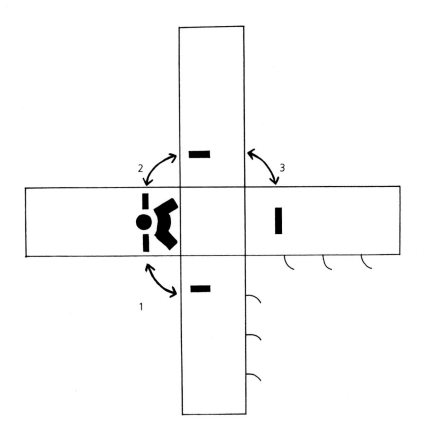

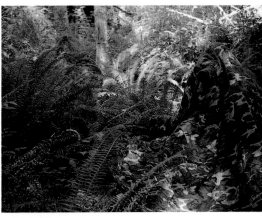

Camouflage Blind
A camouflage blind can be set up in a few minutes.

1. Cut Fabric

Cut four pieces of camouflage or earth-colored fabric 36″ × (your height + 6″) for the sides, and one 36″ × 36″ for the top.

2. Sew Sides to Top

Sew the four sides to the top as shown above.

3. Cut Holes

On one of the sides cut a hole (centered 12″ from the top) 9″ or larger (depending on the size of your lens). This hole should be cut large enough so that your lens and one of your hands can fit through it comfortably. A sleeve must be made that will fit tightly around your lens and attach to the lens hole in your blind. This will allow your lens greater freedom of movement independent from the blind. Cut a piece of fabric about 8½″ long by a width equal to the circumference of the lens hole in your blind. Sew the long sides together. This leaves you with an open-ended sleeve. Add elastic to one end to fit your lens. Sew the other end to the lens hole.

On both sides of the lens hole, 12″ from the top, cut horizontal, oblong peepholes that measure 3″ tall by 8″ wide. Cut peepholes on each of the remaining three sides. Finally, cut the last peephole so that when the blind is just draped over your head, without a framework, you can see out directly over the lens hole and on both sides of your face (see below).

4. Cover Holes

Sew mosquito netting to cover each peephole, allowing you to see out, but keeping birds from seeing inside.

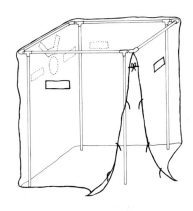

5. Sew Sides

Sew sides 1, 2 and 3 together. The remaining two edges will be your entry.

6. Make Frame

Plastic PVC piping makes a lightweight, inexpensive and collapsible frame for your blind (see above). Support ropes from the corners to the ground will be needed to steady the blind on windy days.

7. Secure Entry

String ties, Velcro, buttons or clothes pins can be used to secure the entry shut when in use.

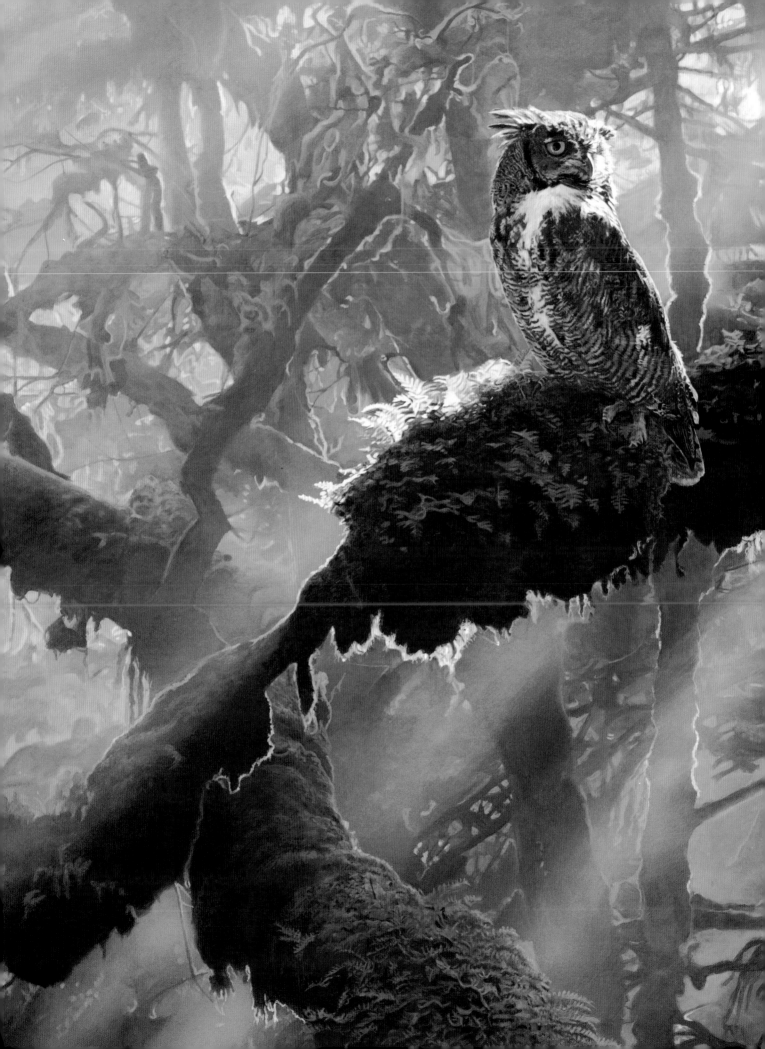

Consider the Environment

On every outing, be sure to consider a bird's surroundings. This is especially important when visiting a place that you might not be able to revisit frequently.

BENEFITS OF FIELD PAINTING

Of course there are advantages and disadvantages to painting on location. The biggest advantage is that everything you need to know about the scene is in front of you. Painting in the field helps you overcome the faults of the camera, gives you a better understanding of the scene, and is one of the best ways to improve your painting ability.

Avoiding Camera Faults

Film cannot duplicate exactly what we see in real life. Color, contrast and tone are often notably different. Painting at the scene allows you to record these elements with more accuracy.

Gaining Understanding

Field painting affords a better understanding of the scene because you must examine it more critically than if you just take a photograph. Concentrating on the most important aspects of the scene, field painting allows you an opportunity to rearrange any elements for a better composition (something that can't be done with a photograph).

Improving Painting Ability

Painting quickly to capture such fleeting elements as changing light is the ultimate way to learn and refine painting skills. It teaches you how to "say more with less paint." In the studio, it is easy to rely on the same techniques and processes that you have always used, but in the field you must reach beyond these to be able to paint any scene quickly.

Be Prepared

Standing or sitting still while painting a scene will invite birds to go about their natural activities around you. Have your camera and/or sketchpad ready for unexpected encounters with birds passing by.

CAUGHT BY LIGHT
(Great horned owl)
Terry Isaac, Acrylic, 30" × 20"
Artwork courtesy of Terry Isaac, copyright 1989, and Mill Pond Press, Inc., Venice, Florida 34292.

Habitat Is Important

The rays of light and the interesting shapes of mossy branches are elements that bring the viewer into this painting. Once you see the great horned owl, you want to explore the intricacies and atmosphere of the surrounding scene.

Completing a Large Painting in the Field

PILEATED WOODPECKER ✒ *Bart Rulon* ✒ *Watercolor*

Executing a major painting in the field can be superior to painting from photos or sketches inside. Find a scene that is close to home and easy to return to day after day, so that you can paint on location when you get tired of working inside. Scenes that are not as affected by changing light situations are best suited for this. You can plan where the bird placement will be when you do your initial drawing for the scene, or wait until the end. The subject may show itself while you

are painting. This will add to the ideas you can use for the bird.

Overcoming changes in light can be tricky. When painting an outdoor scene affected by the sun's changing position, there are two solutions: (1) return to that location only at the same time each day; or (2) do a quick study of what the lighting and values should look like in the finished painting, then refer to it when the light changes. You might also photograph the scene as it should look in the painting.

My Scene and Setup
Since the painting was intended to represent the stump in the shade, I had to stop each morning when the sun reached the old stump.

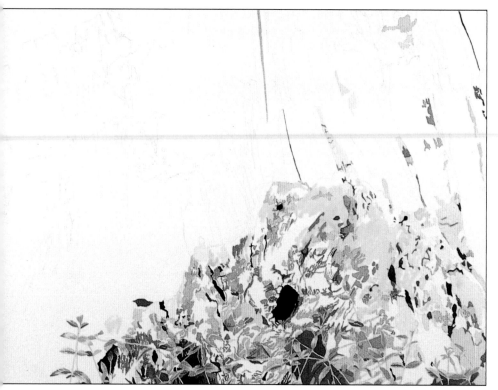

STEP 1

Stump and Foreground
Although I had not actually seen a woodpecker on this stump, the decaying wood with pieces thrown about on the ground gave evidence that pileated woodpeckers had fed here before, making placement of the bird obvious. The old stump was drawn in with all of its major patterns, crevices and outlines, leaving an open spot where the woodpecker would be placed. Next, the vines of periwinkle were drawn in the foreground and painted with as much completion as possible against the white of the paper, using brushes ranging from no. 8 to no. 4. In a few more days the periwinkle would have grown into different positions, causing potential problems in matching the correct lighting with my drawing. Next, most of the recognizable features in the foreground bark were painted in.

STEP 2

Woodpecker, Ferns and Bark

Using a reference photograph, the woodpecker was drawn in, as well as the ferns on the left-hand side of the painting. The ferns were painted quickly, using no. 4 and no. 6 water-color brushes, to avoid possible problems if they were blown or moved out of place. The most noticeable patterns and eye-catching pieces of bark in each stump were painted in for easy reference, using a no. 8 brush with a good point.

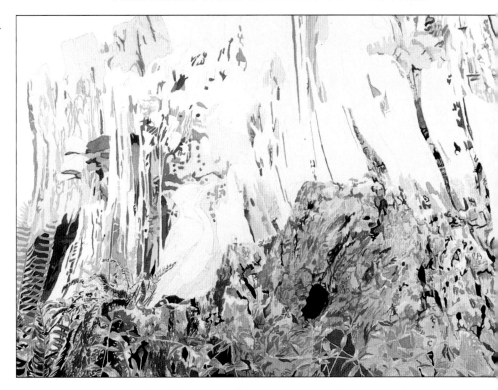

STEP 3

Color Washes

Working all over the painting during each session, I used each color as I mixed it in all the different areas it occurred in the scene. When you have a particular color mixed on the palette, try to use that color up anywhere in the scene that it might occur. This technique keeps the color balance within a painting consistent (very important when working on a painting outside for several days, where the lighting from one day to the next may be somewhat different). Most hues are worked up using a couple of washes. At this stage, details have been painted with washes thinner than they will appear in the finished painting. Elements are painted in very lightly at first, then gradually built up to their true intensity.

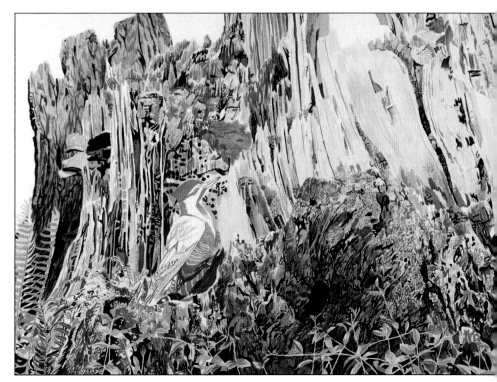

Tips From the Pros

"Judge your sketches by how effectively you can use them in your work, not by what other people might think of them."
—Bart Rulon

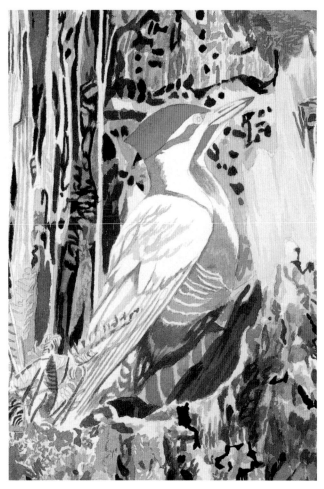

STEP 4

Using Light Washes

I blocked in the color of the woodpecker's crimson crown, as well as feather edges on the back and wings, with a no. 4 brush. I also started to block in the darkest areas on the neck, breast and belly with a no. 8 brush. It is important at this stage to have the feather edges painted so that you don't lose sight of where they should be when you add layers of dark paint over the woodpecker's body. Pencil lines can quickly become invisible with the first wash of color.

STEP 5

A Couple More Washes

Cadmium Red mixed with a little Alizarin Crimson brings the woodpecker's crimson crown and whisker up almost to their full color. A wash of French Ultramarine, Alizarin Crimson, Payne's Gray and Burnt Sienna is laid over the back and wings, and two washes are added to the breast, belly and underparts with a no. 12 round brush. The light markings on the flanks are left unpainted. A light wash of Lemon Yellow Hue is added to the eye and lore (the space between the eye and bill). The edges of the eye and pupil are further defined with the same wash used for the back. These finer details are painted using no. 1 and no. 2 round watercolor brushes.

STEP 6

Using Dark Mixtures

Alizarin Crimson and Cadmium Red, the darkest areas and feather details, were painted on the crown and whisker. Achieving shadow effects on birds with red feathers often calls for thicker mixtures of the same reds that make up the lighter areas, rather than adding blue, black or gray to darken them, because the latter mixtures will muddy the colors inaccurately. Several washes of French Ultramarine, Alizarin Crimson, Payne's Gray and Burnt Sienna were applied to the back, wings and underparts using a no. 12 round watercolor brush. A wash of Burnt Umber was applied to the underparts to show the warm color that would reflect from the bark underneath the woodpecker. The upper mandible of the beak is mostly washed with a cool mixture of Payne's Gray, Winsor Blue and Alizarin Crimson using a no. 4 brush. The lower mandible has a warmer color to it, achieved with light washes of Raw Sienna dulled slightly with French Ultramarine.

STEP 7

The Black Areas

The black areas on the woodpecker were darkened slightly more. Feather indications were added to the white areas. Lastly, the white markings on the wings were added with opaque acrylic paint and a no. 2 round brush.

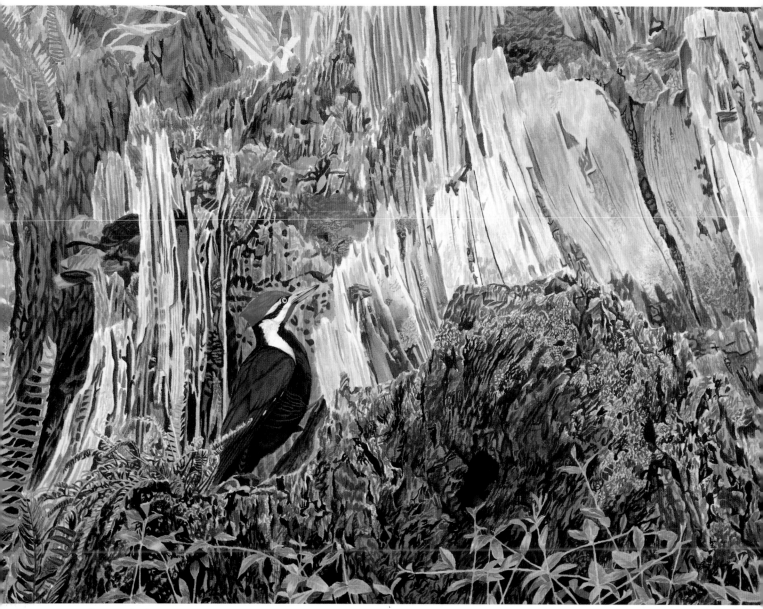

Refine and Finish

Colors are brought up to their full intensity, and edges are refined by adding very intense mixtures in dark areas such as bark crevices. When nearing the end of a painting like this, focus your attention for a period only on the painting (ignoring the actual scene) to decide if some elements would look more convincing exaggerated in one way or another from the way they actually look in real life. In this painting, I exaggerated the contrast a little more from one layer of bark to the next in order to give a better impression of the space between them (to keep the multi-layered stump from looking flat). The background vegetation was loosely depicted using a no. 12 round watercolor brush.

PILEATED WOODPECKER
AND OLD STUMP
Bart Rulon, Watercolor, 22" × 30"

Photographing Habitat

Taking habitat photographs is just as important as taking photographs of birds. When habitat photographs are taken with careful thought and planning, they will become a vital part of sparking ideas and will add to the success of your artwork.

EQUIPMENT

Most habitat photography situations can be handled with lenses ranging from 50mm to 200mm. The 50mm lens is perfectly fine for scenes that you can walk right up to, but the small telephoto power lenses may be more convenient for photographing scenes that are hard to get close to. All of the major camera brands have zoom lenses in the 50mm to 200mm range. These are very versatile, and if you buy only one lens for habitat photos, I would recommend a zoom lens.

CARRYING YOUR GEAR

On trips afield, be prepared. A multipocketed fishing or photo vest works great for carrying lots of gear around without much effort. Backpacks are OK, but it takes time to take them off and scramble through everything to find what you're looking for. With the vest, it's possible to reach your gear more quickly, because everything is organized into different pockets that can be accessed without having to take anything off. You can have your camera around your neck, several lenses, film and sketching pens in the front pockets, and a sketchpad in the large pocket on the back of the vest.

> ### Tips for Habitat Photography
> 1. Take pictures of scenes that you have seen birds in before.
> 2. Take photographs of likely habitats. Think about what birds might be found there and where they would be found in the scene.
> 3. While shooting, move around the scene. Consider different angles, imagining bird size and placement.
> 4. For scenes photographed from far away, it pays to take a few close shots of important details that might not show up well in the broader picture.

Photo Vest

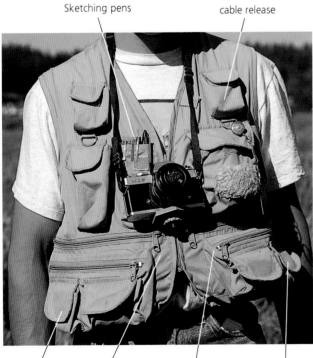

Sketching pens

70-200 mm lens and cable release

Exposed film

Extra camera body and motor drive

Small notebook, 3½" × 5" gray card, and size-reference carving

Unexposed film

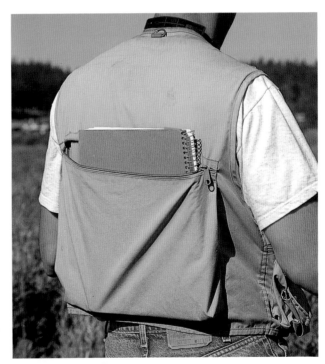

A Sketchbook Fits
Just slip it conveniently into the large back pocket of this kind of vest.

27

Using a Size Reference

One disadvantage of relying on scene photographs without bird references is that the correct size to paint a bird may be unclear. A good way to judge scale in habitat photographs is to place a small size reference in close-up scenes before taking the picture. I carry a small, unfinished wood carving of a shorebird in my photo vest as a size reference. Since I know the exact measurements of the carving, and it is in the shape of a bird, it makes comparing the relative size of the carving and the bird I want to paint very easy. This shortens the drawing process and gives me more confidence in the accuracy of the final product. Since the small wood carving doesn't take up much room in my vest, I continue to carry it afield for those occasions where the scene might be misleading in scale.

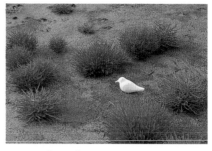

A Woodcarving
Place it for size reference, in the most likely position of a potential subject. The resulting photographs are more useful references.

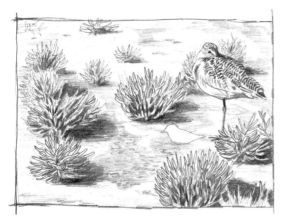

Judging the Scale
Since I know the approximate size comparison of a western sandpiper (the size of my carving) to a marbled godwit, deciding the right scale to draw the godwit in this scene is very simple.

Reference stick
Place a small stick in each photograph if you do not have a wood carving to place in the scene for reference. Bring the stick home, measure it, and note the size for reference.

LATE AFTERNOON
Bart Rulon, Killdeer, Watercolor, 15" × 19"

Size-Reference Stick
Choosing the right scale to paint a killdeer in this scene was made easy with a size-reference stick. I just compared the length of an average killdeer to the length of the stick in the photograph. The size of rocks, waves, driftwood or old logs on the forest floor can be particularly confusing in photographs if they are not surrounded by something else to judge size by.

LONG-BILLED MARSH WREN
Bart Rulon, Acrylic, 12" × 9"

Using Several Different References

Using the material from just one photograph would not have provided an interesting enough composition. No attempt was made to reproduce everything exactly. Paintings have a life of their own, both in brushstrokes and the personal way an artist approaches drawing and painting, qualities that photographs do not have, so don't cheat your creativity by copying photographs. For instance, the out-of-focus background was painted to intentionally show brushstrokes that add more interest than the fuzzy out-of-focus background caused by the camera.

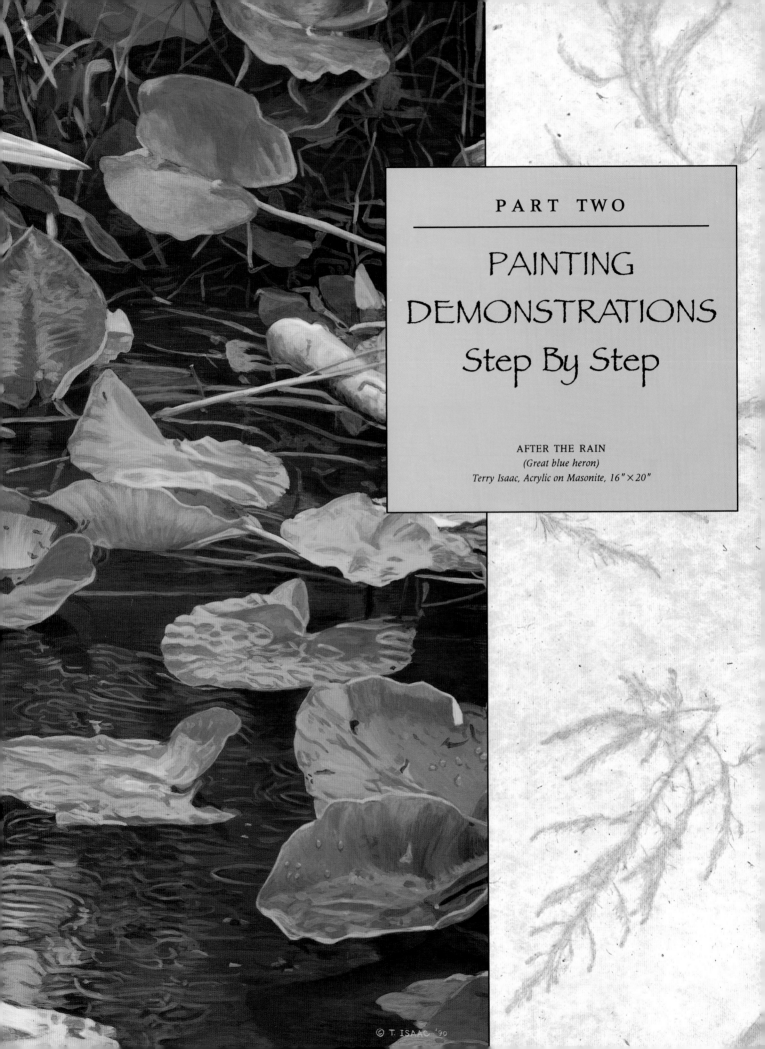

PAINTING
DEMONSTRATIONS
Step By Step

AFTER THE RAIN
(Great blue heron)
Terry Isaac, Acrylic on Masonite, 16" × 20"

© T. ISAAC '90

Capturing Warm Afternoon Light

DOWITCHERS · *Bart Rulon* · *Acrylic*

The idea for *Dowitchers at Sunset* came from spending several days photographing and sketching dowitchers on a lake near my home. The lake is a migratory feeding stop for shorebirds. I followed the birds at close range using hip waders, photographing and sketching them as they fed early in the morning and at sunset. I wanted to use an idea that would emphasize the warm lighting as it hit the dowitchers and their surroundings.

STEP 1

Planning the Composition
Starting with two dowitcher gestures, I did several thumbnail sketches before deciding to place the birds close together and overlapping slightly. I decided a third bird would look best on a slightly different plane than the other two.

Rulon's Acrylic Palette
Titanium White, Cadmium Barium Yellow Light, Yellow Ochre, Raw Sienna, Raw Umber, Burnt Sienna, Cadmium Red Light, Ultramarine Blue, Ivory Black

STEP 2

Preliminary Drawing

After drawing in details on gessoed Masonite, cutouts of possible poses were placed for comparison. I made pencil tracings on the backs of these and pressure-transferred them to my board.

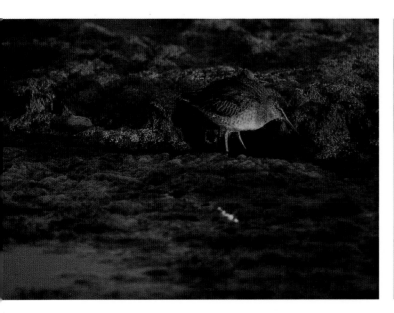

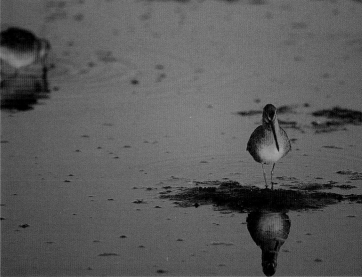

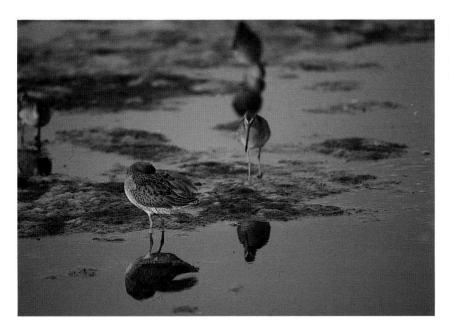

Reference Photographs

These three photographs served as color and anatomy references for the painting.

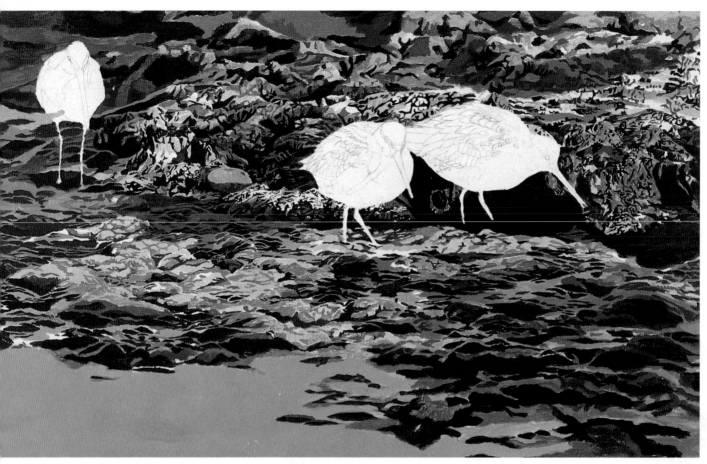

STEP 3

Blocking in the Scene

I began by using blocks of color, quickly covering the painting surface using a Winsor & Newton 505 Sceptre no. 12 flat brush. This gives an approximate color balance for the entire scene that can be used to compare relationships for better mixing of pigments. Lastly, a few mud crevices were painted with a no. 2 round worn down to a good point.

Scene Palette

Water: Cadmium Red Light, Ultramarine Blue, Titanium White

Algae: Raw Sienna, Cadmium-Barium Yellow Light, Ultramarine Blue

Mud: Raw Umber, Ultramarine Blue, Ivory Black

Distant Shadows: Cadmium Red Light, Raw Sienna, Ultramarine Blue, Titanium White

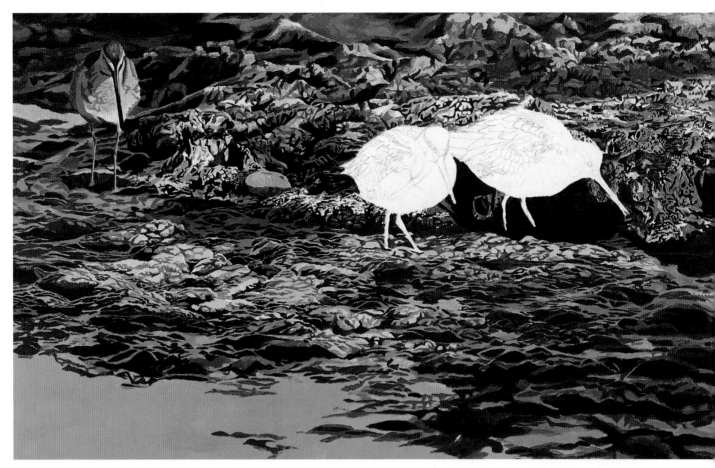

STEP 4

Filling in the Left Side

Many dark crevices were painted next. I also started working on the wet foreground mud. I filled the left background in with more accurate colors (darker blues and greens), then roughly painted in the left dowitcher. This stage was done with a 635 Strathmore no. 2 filbert bristle brush and a no. 3 bristle round.

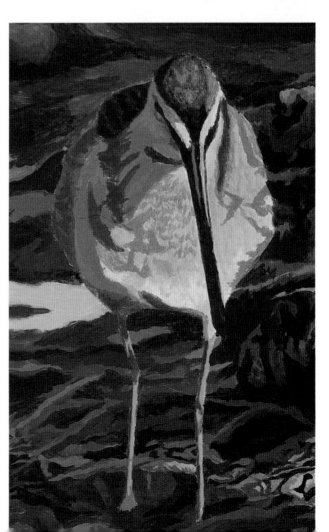

STEP 5

Blocking in Dowitchers

I started out by blocking in major values using the no. 2 filbert and the no. 3 round. Many feather markings from my drawing were included, so that I knew exactly where they would be before approaching any details.

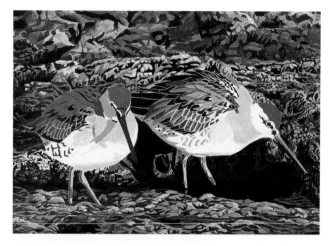

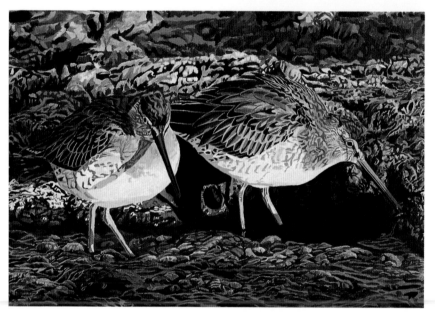

Breast and Leg Palette

BREASTS

Sunlight: Raw Sienna, White
Shadows: Raw Sienna, Ultramarine Blue, Titanium White

LEGS

Cadmium Red, Cadmium-Barium Yellow Light, Ultramarine Blue, Titanium White, Ivory Black

STEP 6

Feather Patterns and Markings

I started by painting in the darkest area of each feather, using varied mixtures of Ivory Black and Raw Umber. I let a narrow strip of light underpainting show through to indicate where the feather edges were. I filled in the lightest patterns, then glazed intermediate values between the lightest and darkest parts of each feather. All these mixtures varied depending on the color balance of the individual feather. The brushes used during this step were the Winsor & Newton Sceptre Gold 101 no. 4 and no. 2 watercolor brushes. For the dark cap on the birds' heads I started out with a uniform underpainting. Next I painted in the darkest feather values on the cap by adding Ivory Black to the initial mixture. Lastly, the very lightest cap feathers (catching the sun) were glazed on slowly for a subtle transition. The feather markings on the necks, breasts, sides and flanks were then roughly blocked in. For the middle bird I repeated the general feather markings and patterns found in the bird on the right, but since these two birds are standing at different angles one can't tell that the patterns are almost the same. A few more washes of Raw Sienna were added to the breasts and necks of the birds to add more warmth.

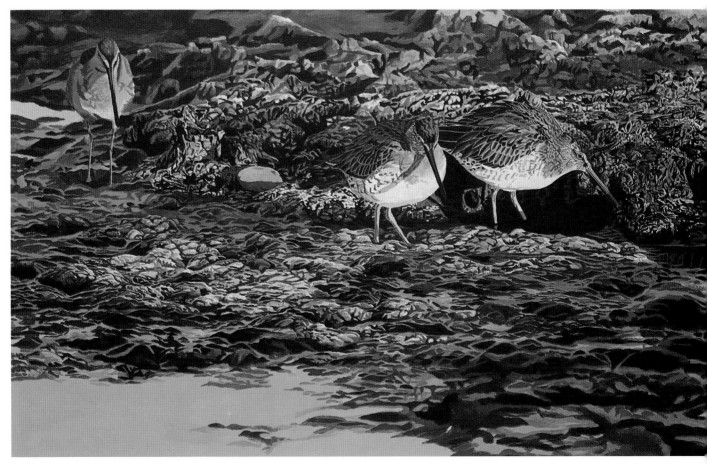

STEP 7

Manipulating Values

I worked areas all over the painting from dark to light, and light to dark, until the value transitions looked right. While working on the foreground, I mixed about four base colors of green, consisting of Ultramarine Blue and Cadmium Barium Yellow Light with Raw Umber, Raw Sienna, Ivory Black and Titanium White for the different shades. I also mixed intermediate colors for particular areas as needed, treating each little section of green individually by picking up on differences in color and value so that the whole mass of green did not look unnaturally uniform. At the end of this stage I realized that the green values were too bright.

Feather Pattern Palette

CAPS ON HEADS

Underpainting: Burnt Sienna, Raw Umber, Ultramarine Blue

FEATHERS

Darkest: Burnt Sienna, Raw Umber, Ultramarine Blue, Ivory Black

Lightest: Raw Sienna, Burnt Sienna, Raw Umber, Titanium White

NECK, BREAST, SIDE AND FLANK MARKINGS

Raw Sienna, Ultramarine Blue, White

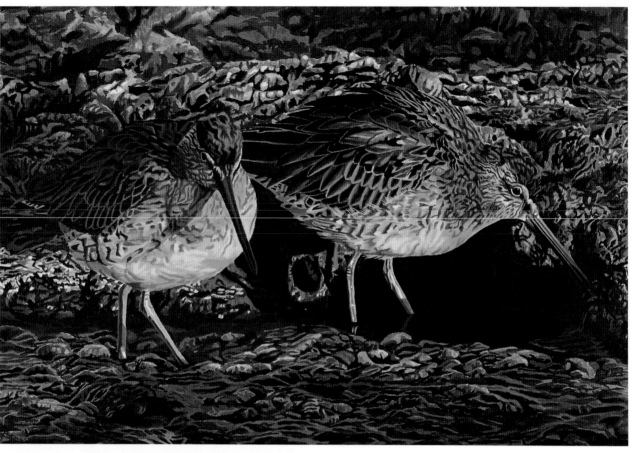

STEP 8

Finalizing Markings on the Birds

Finishing off backs and wings, I darkened some markings (in shadow), adding a slight blue reflection from the sky on the back of the closest bird. Minute glazes were added for subtle color transitions, and to indicate shadows. Most feather edges were toned down with dark glazes of Raw Umber, Ivory Black and a little white. The neck, breast, side and flank markings were feathered out with dark and light glazes, trying to keep the edges soft. Several mixtures of Raw Sienna and Titanium White were used for the lighter areas on the bellies. The lightest mixtures were used sparingly because too much white kills the intensity of Raw Sienna needed to portray the warmth of the setting sun. As a last step, on the right-hand bird I used a no. 1 watercolor brush and a diluted wash of Raw Sienna and white to paint a few split side-feather edges, which overlap the folded upper wing.

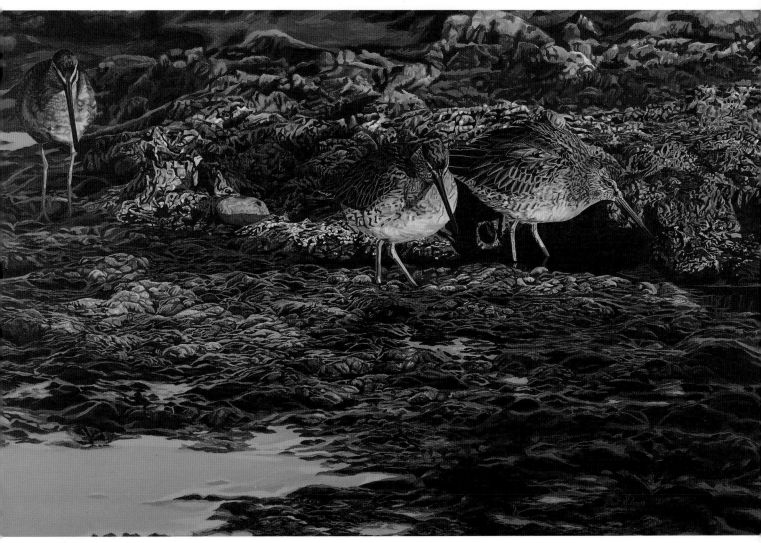

STEP 9

Finishing Details

Much time was spent toning the greens down and color correcting them. I corrected other color or value problems and refined transitions between colors while adding the finishing details. At this stage in a painting you should be looking less at reference photographs and concentrating more on what needs improvement according to your own vision. I decided to add more mud shapes in the middle bottom foreground to help the composition. I mixed the colors for the water again, so that I could use a wet-on-wet technique to blend the slight gradation of color and value on the water's surface using a no. 12 flat brush and a no. 2 filbert. Glazes of different brown mixtures were added to the clumps of mud in the foreground to help warm up the excessively cool color balance. Also notice how warm refelections (in different intensities) are glazed into the mud under the birds to indicate their glowing color.

DOWITCHERS AT SUNSET
Bart Rulon, Acrylic, 17" × 27½"

Attention to Accuracy

Canada Geese ✒ *Dave Sellers* ✒ *Oil*

Dave Sellers's idea for this painting came soon after acquiring a pair of cackling Canada geese for his live waterfowl collection. "To me . . . good art is little more and nothing less than a good, original idea," says Sellers, "but to get the idea across in a pleasing way requires attention to accuracy." He says "the most difficult areas of a bird to capture are the eyes and feet. I try to work out these areas in the drawing stage. . . ."

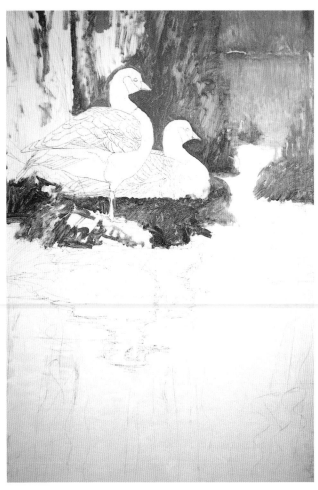

STEP 1

Background

Sellers applied two light coats of a Raw Umber and Titanium White mixture as a warm underpainting. "I always start with what is furthest back atmospherically." He avoided too much detail in the background, using color blocks mixed for correct value. "This helps simplify the work to the skeleton of its composition. I am never a slave to my drawing. Colors for this stage were Burnt Umber and Cerulean Blue with . . . white and a little Naples Yellow and/or Violet." Many large areas were executed with a no. 10 oxhair bristle flat brush.

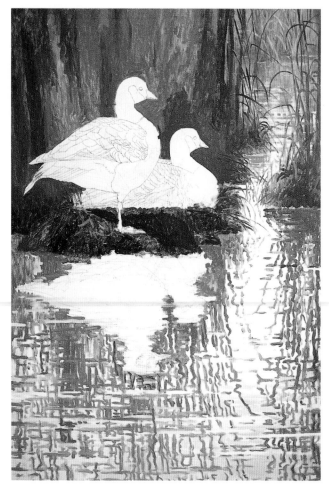

STEP 2

Highlights and Shadows

At this stage, Sellers says, "I've used Naples Yellow and Cobalt Violet mixed in greatly varying proportions to achieve highlight colors as well as shadows. I added Cerulean Blue . . . to achieve cooler shadowy colors and Cadmium Orange and yellow with white to get the warm highlights." He enjoyed developing water reflections, saying, "I tried to make it look as much an appealing array of pattern and color as a representation of reflected grasses."

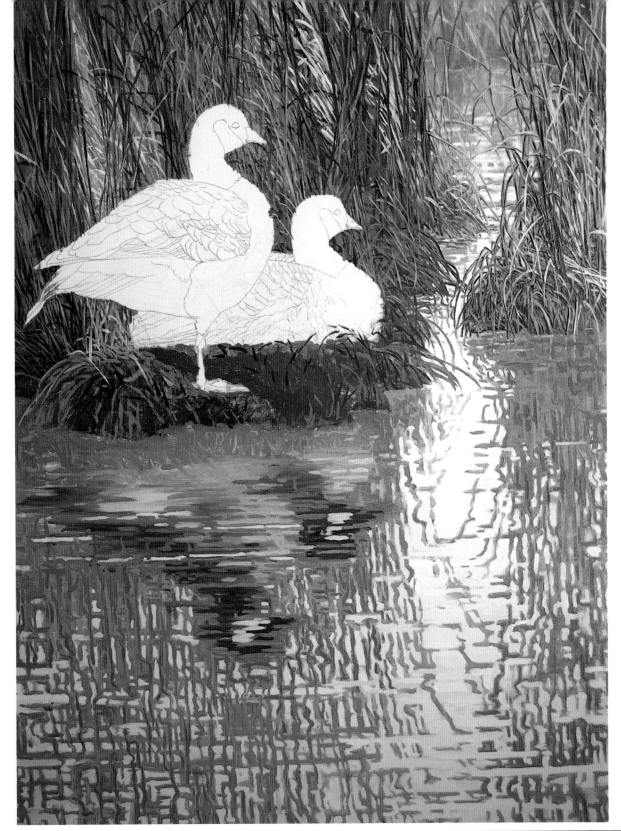

STEP 3

Grasses and Reflections

"I knew it would be a challenge getting the reflections of the geese to blend well with the pattern of the reflected grasses, so I painted them with the same brushstroke, painting wet-on-wet and 'weaving' them into the mosaic. . . ." Sellers painted dark grasses in front of the highlighted ones to develop depth. The grasses and reflections were painted using a no. 8 bristle filbert, as well as a no. 6 round bristle for the more detailed work and some areas on the geese.

Sellers's Oil Palette
Titanium White, Burnt Umber, Burnt Sienna, Ultramarine Blue, Cerulean Blue, Cobalt Blue, Naples Yellow, Cadmium Yellow, Cadmium Orange, Magenta, Cobalt Violet, Poppyseed oil (as a medium)

41

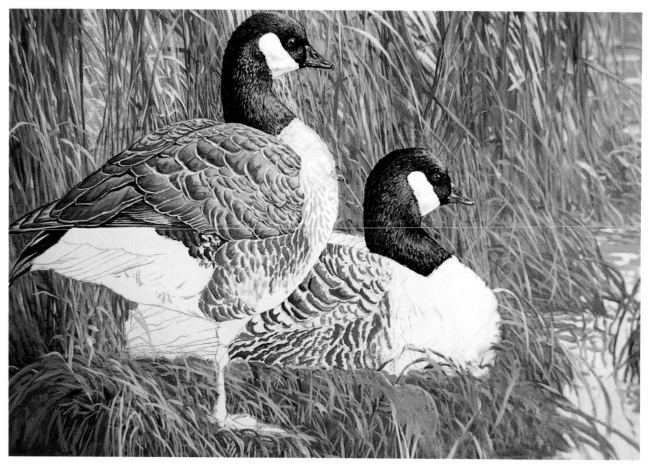

STEP 4

Blocking in Values

For most of the geese Sellers used a no. 4 synthetic sable round. His favorite brand is Winsor & Newton Sceptre Gold. Though he generally works from dark to light on the subject, Sellers blocked in the bright white of the cheek patches first, then blended shadow colors (those of the water and grasses reflected back on white) wet-on-wet. A no. 8 filbert was used to paint the necks, tails and white cheek patches.

For the necks, Sellers starts out with a black coverage, then works in feather values wet-on-wet. The brightest highlights, however, are added when the paint is dry, so as not to dull them too much. Sellers uses the same dark-to-light technique on the bills.

Eyes

For the eyes, Sellers first painted in the color of the iris and the dark pupil and let this dry. For a reflection of the surroundings, he split the eye in half, top to bottom, with the middle reflecting the horizon line. On the top his reflection mirrored the sky, with the top right corners having a bright highlight reflecting from the sun and the top left side having a duller blue reflection from the blue sky. The iris color was painted the brightest on the bottom half of the eye because this is where the sun shines through the eye to catch the iris and make its color shine the brightest.

For sides, flanks and breasts, Sellers starts out by painting a dark to medium value representing the middle of each feather with a mixture of Cerulean Blue, Burnt Umber, Cobalt Violet and white.

STEP 5

Detailing the Feathers

"A beginning painter will often assume that the brightest highlights . . . will be at the ends of the feathers. . . . Most feathers, however, are quite rounded and somewhat shiny; this characteristic will cause light to be reflected mostly at the base. . . ."

With breasts, sides and flanks still wet, Sellers paints in the feather edges with a light mixture of Naples Yellow, Cobalt Violet and white. These are then blended wet-on-wet into the midtone of the feather. Dave likes using Naples Yellow because it doesn't turn greenish when mixed in this situation. Next to the highlight of the feather edges, Dave paints a blue mixture of Cerulean Blue, Burnt Sienna and white. So most feathers go from the blue to the core feather color to the highlighted feather edge. Brushstrokes are executed in the same direction the feather barbs grow.

Mixing Blacks

Sellers mixes Burnt Umber and Ultramarine Blue together for his blacks.

Skillfully Controlling Contrast

Sellers develops more contrast in the geese than the surrounding grasses. He says, "This helps to bring the birds out, but it is important to know how subtle the difference should be. If it is overdone, the entire piece can look contrived."

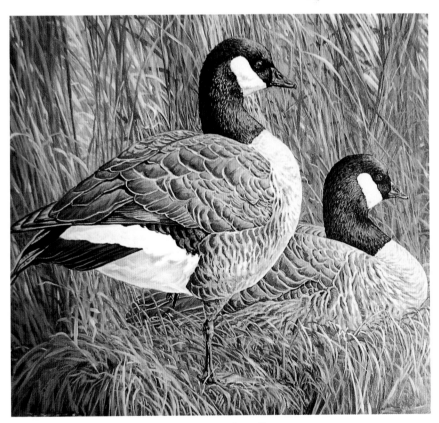

Detail

43

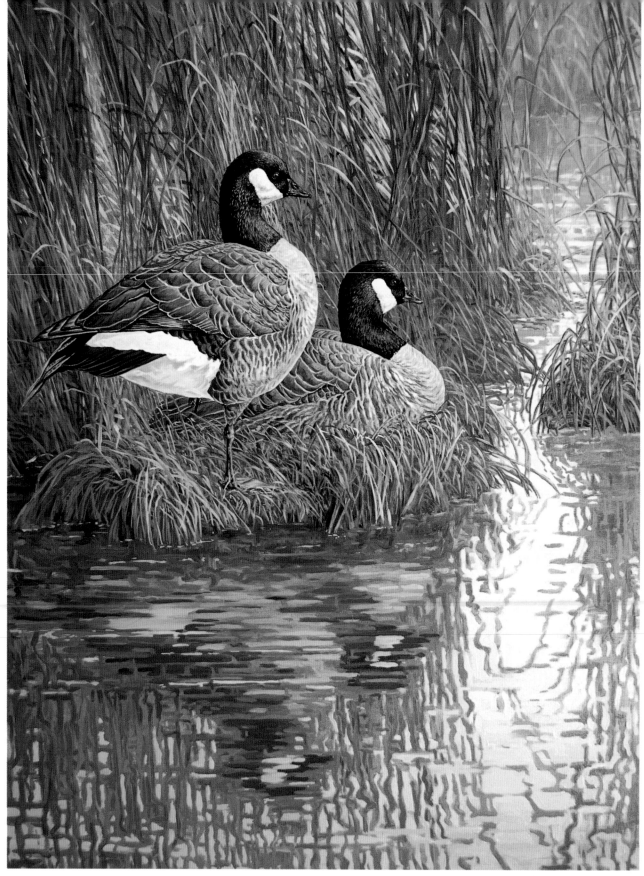

STEP 6

Finished Painting
Sellers finally builds and cleans up the reflections.

CACKLING CANADA GEESE
Dave Sellers, Oil, 36" × 23½"
Collection of Pete and Diane Lawrence

Artist Dave Sellers maintains a collection of twelve species of waterfowl, which, he insists, is "a wonderful way to get to know the birds, but not a substitute for wild birds in the wild." Close-up observation of his own waterfowl allows him to see details that supplement his many experiences sketching and photographing waterfowl in the wild, "using techniques ranging from a blind to a kayak."

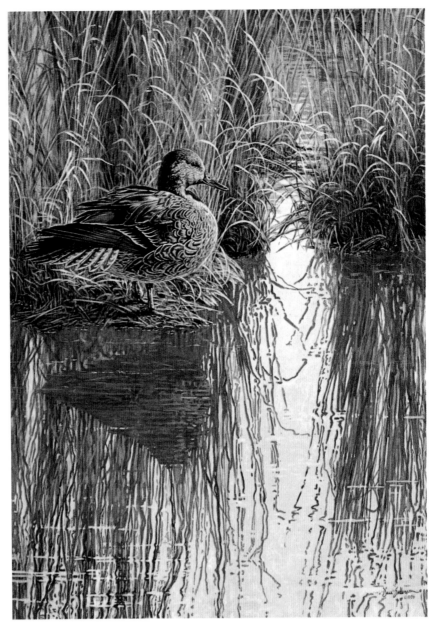

LONE PINTAIL HEN
Dave Sellers, Acrylic on gessoed rag board,
14"×24"

What to Leave In, What to Take Out

CANADA GEESE ✐ *Jay J. Johnson* ✐ *Oil*

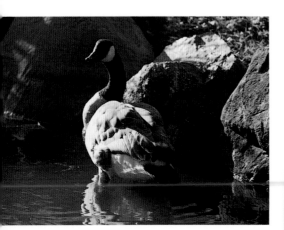

"The idea for this painting came from a scene near my home where I was struck by the unusual shape of the snowbank," says Jay J. Johnson. He photographed the scene using Fujichrome 100 slide film, knowing that he would paint a more subtle, softer version. "I don't believe it's possible to take too many slides, since it only increases the chance of capturing something truly extraordinary."

REFERENCE

"I envisioned two Canada geese sitting in the foreground and went looking through my slide collection for the appropriate ones. Posture and, most importantly, correct lighting were what I was searching

for. . . ." The slides he chose were of the same bird, but he distinguished the two by painting in slight changes between them. "One problem with the slides was that the highlights were overexposed," says Johnson, "but, using close-up slides of other goose feathers, I overcame this."

PRELIMINARY "SKETCH"

Using the color slide of the scene, Johnson makes a black-and-white photocopy in this case, but he will often do a pencil drawing or small study in oil paint. He then makes several different cutout drawings of the geese to determine correct relative sizes and placements.

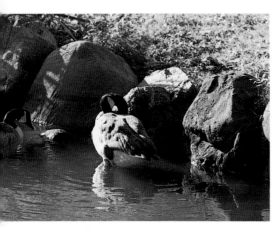

Reference Photos

Preliminary "Sketch"

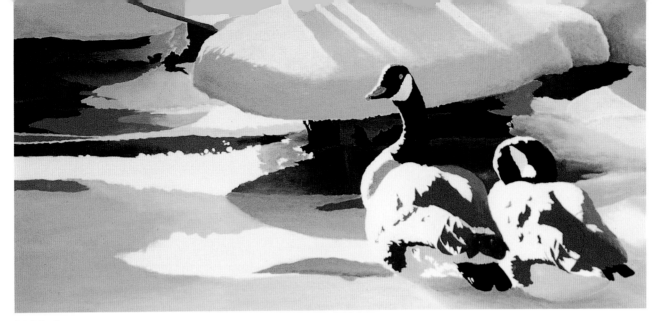

STEP 1

Blocking in the Basics

The composition having been determined, Johnson gessoes a Masonite panel and is ready to start painting. During the first session, he says, "I started by mixing colors on the palette and applying them on broad basic areas until I achieved the shades that seemed to work best together." Johnson then mixed larger amounts of these colors, and stored them in 35mm film canisters. This saved time later on.

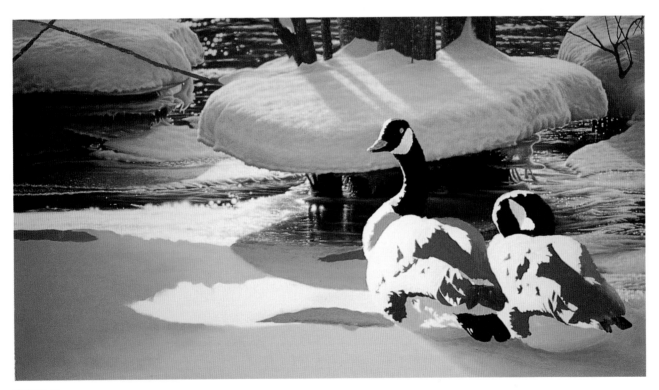

STEP 2

Developing the Scene

Next Johnson started developing each area of the scene wet-on-wet until a certain amount of realism was achieved, knowing that he would later return to make any needed improvements. "To achieve a glittering effect on the snow and ice," he says, "it was necessary to first make the highlight areas somewhat darker so that the glitter stood out."

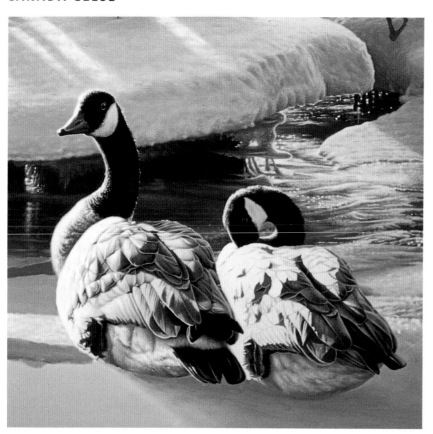

STEP 3

Lighting

Having the background developed helped Johnson "fit" the geese into the scene. ". . . their colors are not as seen in the reference slides," says Johnson, "but correspond to the background of the painting. The light and atmosphere are much different than that of the warmer, greener season during which the slides were taken, and that difference has to be taken into consideration when painting the geese."

Johnson outlined the feather edges and then blended from light to dark within each feather. The backlit necks and heads started with an edging in white. Next Jay glazed color over the white edges, softening and toning them. He spent a lot of time at this, not wanting the backlighting effect to stand out too much. Adding warmth to the cheek patches helped differentiate them from the cooler snowbank behind.

Back and Wing Palette
BROWN FEATHERS

Base Mixture: Raw Umber, Burnt Umber, Titanium White
Darker Edges: add Ivory Black to base
Warmer Parts: Yellow Ochre, Cadmium Yellow Deep
Top Edges: Phthalocyanine Blue and/or French Ultramarine

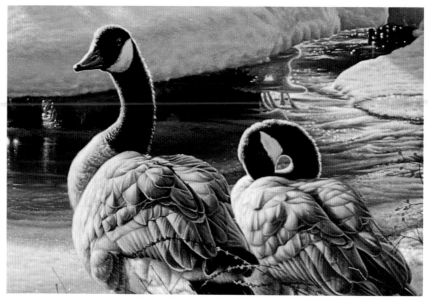

STEP 4

Backs and Wings

For each goose feather on the backs and wings, Jay laid in the lightest and darkest areas first, then blended wet into wet.

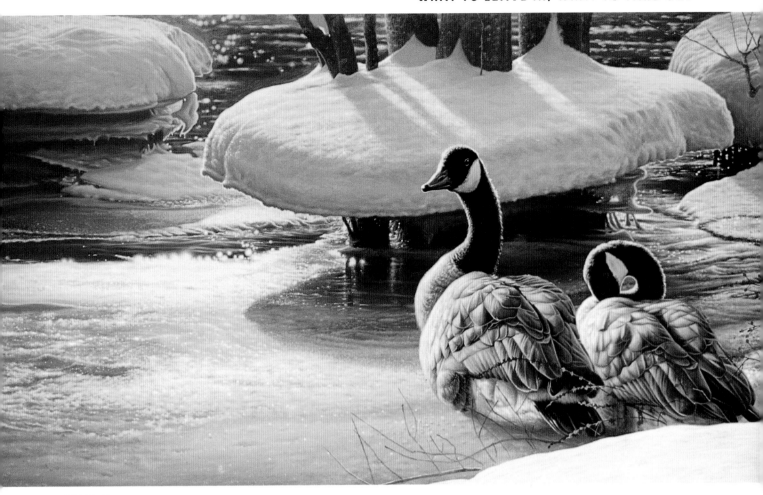

STEP 5

Compositional Adjustments

At this point Johnson decided on some adjustments. He removed limbs at upper left. Background water and highlights were toned down. The areas around the geese were blended and darkened. "Most importantly, I wanted to bring the geese into the painting by putting a snowbank in front of them," says Johnson.

> *Tips From the Pros*
>
> The complexity and symmetry of feathers requires much patience. . . . Any irregularity is noticeable. . . . In birds, unlike mammals, there are a lot of 'compartments' or parts that often have to be treated separately. Feathers form their own units and this makes it different from painting fur, which is generally all the same texture.
>
> —*Jay J. Johnson*

Corrections and Finish

Johnson says the finishing touches "mostly involved softening edges, lightening dark areas, darkening light areas, reinforcing shapes or patterns, adding glazes to enhance certain colors, strengthening the illusion of reality, and bringing all the parts together into a harmonious image. Much of this work was done with very thin paint." The bright highlight rounding the entire outside edge of the right goose's neck looked too bright to Jay, so he darkened the edge on the lower half with glazes of color.

Johnson decided the painting was finished when it was close to matching his original mental concept for the artwork. "When it has a feeling of realism or looks like the bird is going to fly off," Johnson says, "it's probably done. Usually I try to achieve an illusion of reality when seen . . . three feet away from the surface of the painting."

As a last step, Johnson sprays on two layers of Kamar varnish (manufactured by Krylon). He applies this soon after the piece is dry. It "brings the paint colors instantly to life." For this reason he often uses varnish during the painting process to better assess the piece (during the painting process it is advisable to use just one light coat of Kamar).

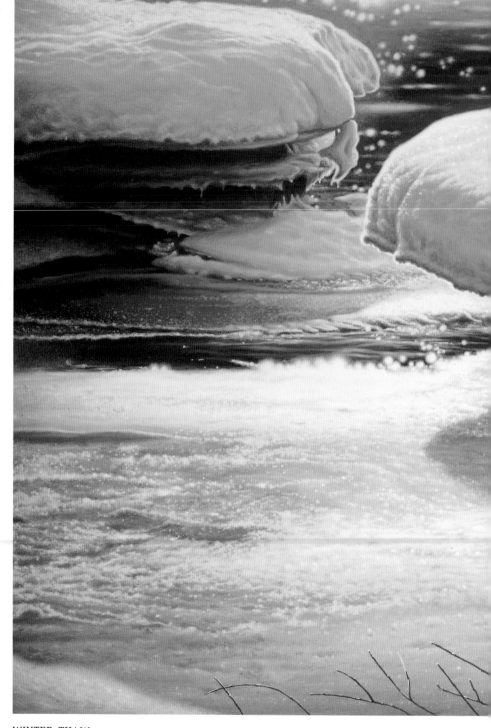

WINTER THAW
(Canada geese)
Jay J. Johnson, Oil, 14"×25"
Artwork by Jay J. Johnson, copyright 1994, The Greenwich Workshop, Inc. Reproduced with the permission of The Greenwich Workshop, Inc.

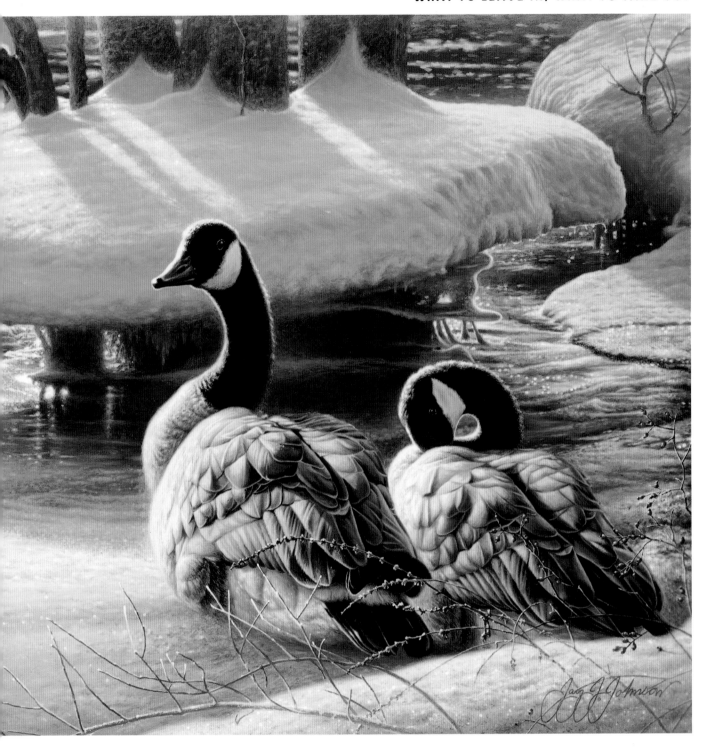

Painting Wet-on-Wet With Oils

D U C K L I N G 🍂 *Jay J. Johnson* 🍂 *Oil*

Jay J. Johnson's inspiration for this painting came from a combination of two experiences. In the spring he spent a morning watching ducklings at a local nature center, and a few weeks later saw more ducklings during a kayak trip on the Concord River.

Painting Surface

Jay Johnson paints exclusively on Masonite hardboard for his oil paintings. He says, "other brands of hardboard may be flaky and come apart. I like the smoothness of Masonite and the firmness. It's also more rugged and durable than canvas, and it packs easily for shipping."

He prepares his panels with three to four layers of gesso (including back and edges to prevent warping) applied with a very soft 1½" brush, sanding between layers. In addition, Johnson says, "Around the borders I put a ⅛"-wide piece of removable tape that is typically used for covering up typing errors. I leave this on until I'm finished with the entire painting process, then peel it away so that I have a perfectly straight-edged white border. . . . When the painting is framed, very little of the image is covered up. . . . It also helps in preventing damage . . . since accidents (chipping, fingerprints, etc.) happen mostly on the edges. . . ."

Pencil Sketch

Johnson first did a sketch to work out size, composition and balance.

Johnson's Oil Palette

Cadmium Lemon, Winsor Yellow, Cadmium Yellow Medium, Cadmium Yellow Deep (orange), Cadmium Red, Bright Red, Cadmium Red Deep, Mauve Red Shade, Cobalt Blue, Ultramarine Blue, Permanent Green Deep, Oxide of Chromium (green), Chrome Green Deep, Naples Yellow, Yellow Ochre, Raw Sienna, Burnt Sienna, Burnt Umber, Raw Umber, Lamp Black, Ivory Black, Titanium White

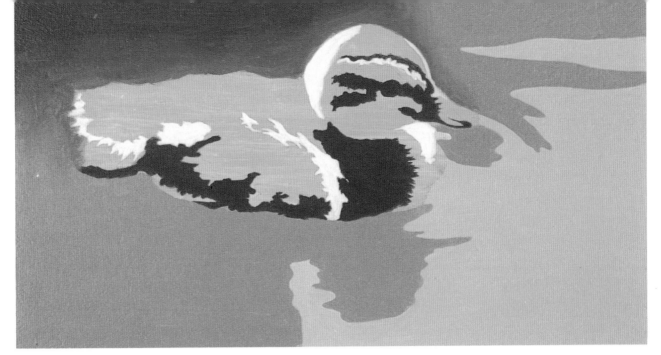

STEP 1

Blocks of Flat Color

Johnson started painting by applying blocks of flat color, keeping in mind how the areas in the water compared with each other. "By adding a little blue to the brown areas and vice versa," Johnson says, "I arrived at shades that worked well together. . . . The duckling blends in nicely, and as an undercoat I've started with a shade similar to the brown water." He saved these colors in 35mm film containers to use throughout his work on this painting.

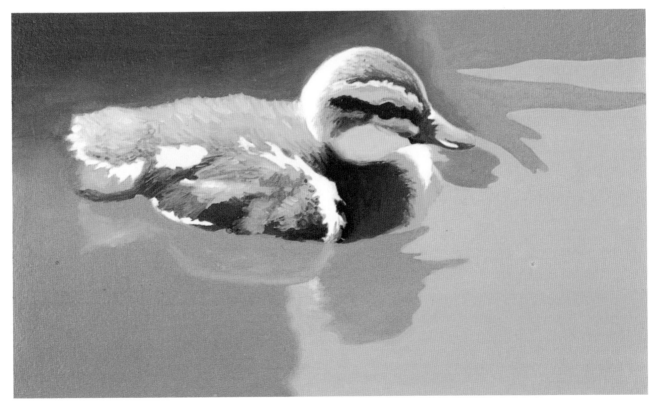

STEP 2

Foundation for Realistic Work

Johnson applied thin layers, aiming toward a three-dimensional effect. He softened edges and added some details, adjusting his initial colors slightly.

For the bright to dark transition on the duckling's breast, Johnson first laid in the two extremes, and also an intermediate value to help in the transition that would be blended later. The bird's bill was further painted with blocks of color.

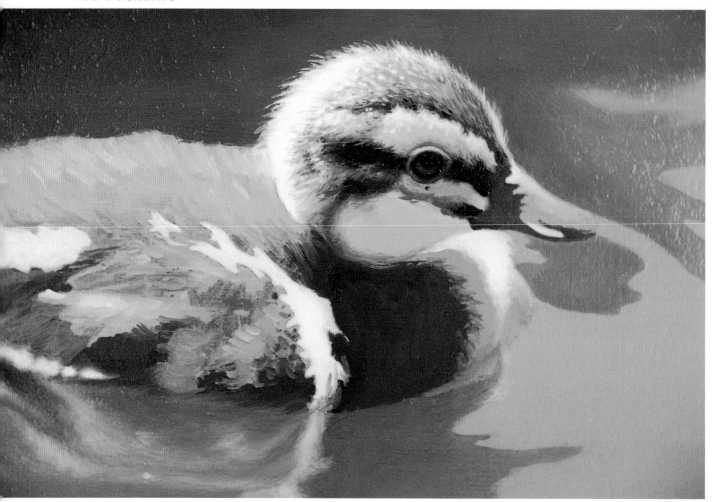

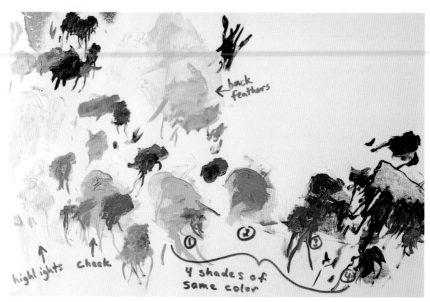

← back
feathers

high lights cheek

4 shades of
same color

① ② ③ ④

Palette in Progress

Johnson used four shades of one color for the duckling, applying each with a separate brush. It is important to remember that colors look darker against a white palette than they do in a painting. Compare, for instance, the cheek color on the duckling and on the palette. "Colors appear differently depending on what surrounds them or is adjacent to them. For example, gray seen on white appears dark, while the same gray on black appears light."

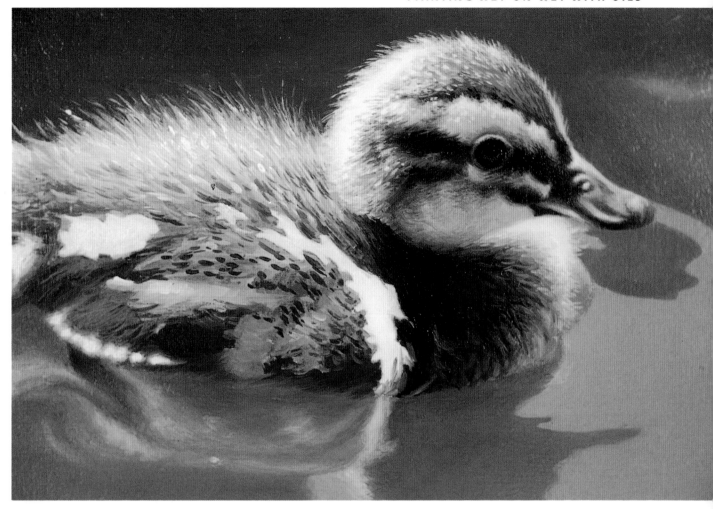

STEP 3

Downy Feathers

For feather details, Johnson started by wetting each area of the painting with a thin layer of paint (previous page). Then he blended darker and lighter colors wet-on-wet from his palette. ''In particular it was helpful to have the water behind the duckling's back wet first before painting in the downy back feathers,'' says Johnson, ''since this allowed for a realistic blending of the hair-fine strokes with the water.''

The transition between bright and dark areas of the duckling's breast was blended wet-on-wet using one brush each for the lightest and darkest colors. A middle tone was applied, then the dark was worked into the bottom and

the lighter mixture on the top. Johnson kept in mind the direction and subtle shapes of the downy feathers as he worked. Refined linseed oil was used as a medium for maximum blending time. The bill was also finished off using a wet-on-wet technique.

Jay J. Johnson likes using the wet-on-wet technique for painting downy feathers since they are so soft. He tries for more of an overall feeling of fuzziness with downy feathers, rather than trying to paint individual feathers like those on an adult bird. ''I'm striving for three things at this stage,'' says Johnson, ''a strong sense of light . . . , the softness of the feathers, and true colors.''

STEP 4

Soft Touches

Johnson continued to work on the feather textures on the front area of the wing and softened feathers wherever needed with touches of paint "here and there." He also began to soften reflections in the water. The water at this stage has a cool blue-green tone.

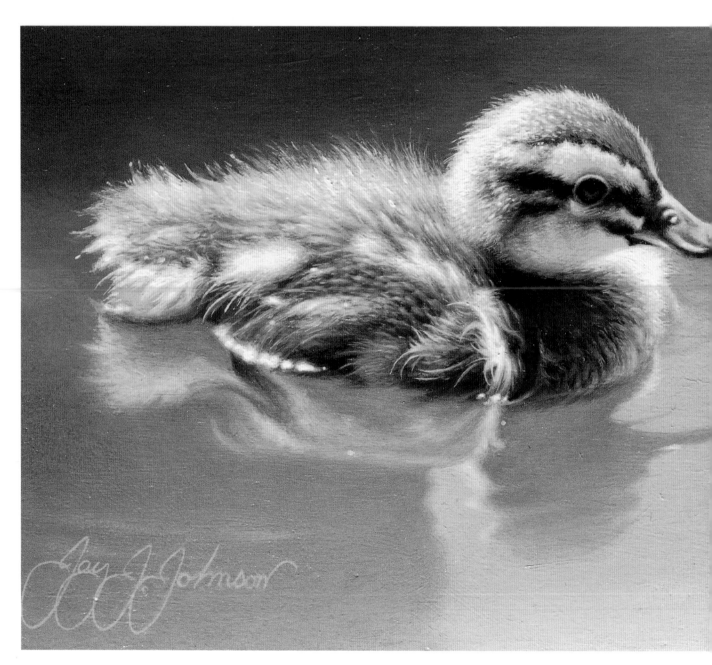

STEP 5

Glazes of Color

At this last stage, Jonnson turned his attention to finishing the water. "Now I'm working on the water by exaggerating the transition from dark in the upper left to light at lower right." Johnson again applied a thin paint layer and worked wet-on-wet. "Here is where the stored 35mm film container paint comes in handy. . . . The fact that wet paint looks slightly different from dry paint makes having premixed paint easier to match." Toward the lower right of the blue water area Johnson added white. Toward the bottom of the brown reflection he added blue.

"The reflection of the head is substantially softened, more so than you would actually see in nature," says Johnson. He then harkened back to a childhood memory of an optical effect, saying that "as a youngster floating on an inner tube . . . I remember marveling at how sunlight penetrating the water beneath me turned the water translucent yellow." To achieve this effect, Johnson glazed over the water with pure yellow after the paint was dry.

As a final step for the duckling, Johnson selectively added warm glazes to some feather areas, including the colors Raw Sienna, Burnt Sienna and Cadmium Yellow Deep. Some darks (like just under the cheek) received darker glazes of color, which added more contrast.

DUCKLING
Jay J. Johnson, Oil, 4¼" × 7⅛"

Painting Groups of Birds

CHICKADEES ✒ *Jay J. Johnson* ✒ *Oil*

Jay J. Johnson found the inspiration for this painting on a river in Maine. He was particularly interested in the cool colors, and in the arrangement of leaves and rocks in the foreground next to this waterfall. He decided that an elongated combination of two photographs would best capture both the waterfall and the foreground. Johnson wanted to use a group of small animal subjects with this scene. "I've seen chickadees moving in flocks so many times in the woods of New England that they seemed the perfect complement to this scene," says Johnson.

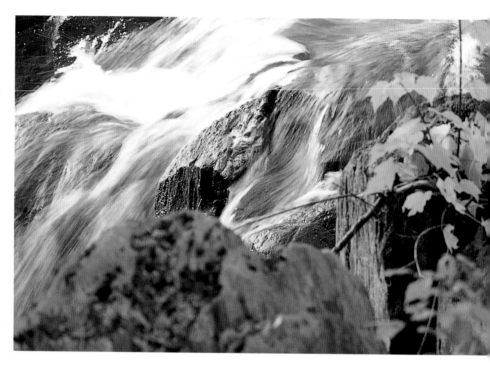

Photo References

> ### Tips From the Pros
>
> Try to avoid the common poses that we typically see in paintings and strive to find postures that elicit more of the bird's character and interesting aspects.
>
> —*Jay J. Johnson*

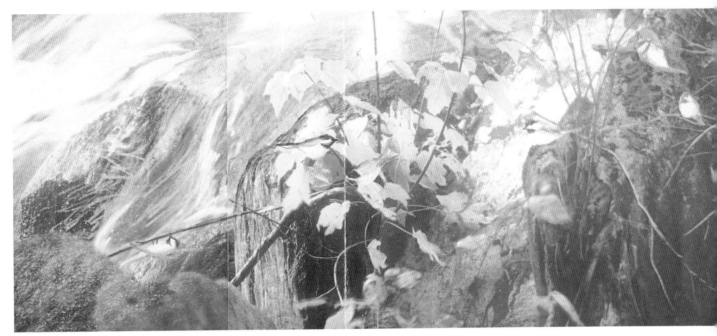

Preliminary Sketch

Johnson next made color photocopies of two slides and pasted them together, forming an elongated image. "I then used strips of neutral gray mat board to crop the edges down . . . ," says Johnson. "I then worked directly on the color copy image with pencil and white oil paint to darken or lighten areas. . . ." He partially eliminated the rock in the lower left, and made the water much lighter than in the photo. The chickadee placements were decided upon using paper cut-outs.

STEP 1

The Foundation

Johnson's first step was to paint a light blue covering the entire gessoed surface. Next, "Cover the Masonite with solid colors. . . ." Doing this allows for thinner layers in subsequent steps. "For roughing in," Johnson says, "I'll use flat brushes, all synthetic fiber . . . I sometimes also use a 'fan' brush to blend wide areas."

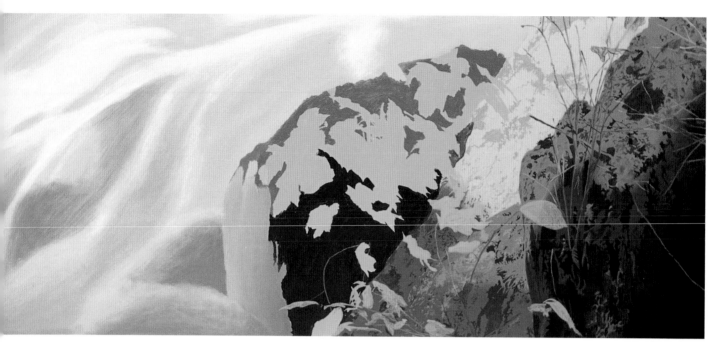

STEP 2

Mapping in Larger Details

Johnson continued establishing his foundation, but with a bit more detail, especially in the rocks. "I've begun to 'draw' the location of details such as limbs and spots on the rocks," says Johnson. "Mapping these out now . . . allows me to concentrate on other aspects more freely."

Johnson also began softening edges in the waterfall, he says, "making it easier to paint over later and obtain realistic-looking water."

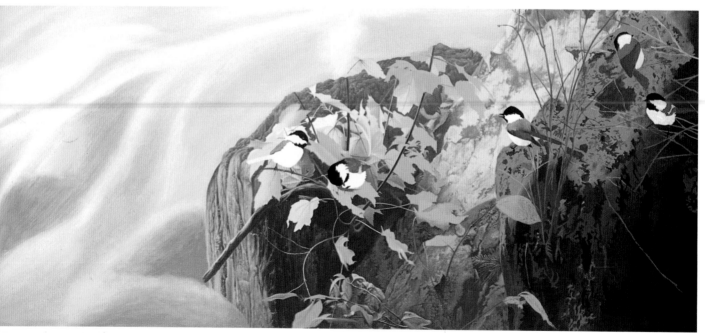

STEP 3

Positioning the Chickadees

After letting his foundation colors dry, Johnson started to work on the details of each part of the painting. In doing this, he says, "I'm keeping the colors cooler and subdued because the light in this particular scene is indirect, almost shady."

"Once roughed in," Johnson says, "I predominantly use no. 0 and no. 1 brushes to render most of the painting The brand of brush doesn't matter to me as long as the bristles make a perfectly fine point."

Using his sketch as a general guide, Johnson next positioned the chickadees into the painting, fine-tuning their sizes and positions by using slides of birds he had photographed at his bird feeder. Johnson says, "I was looking for unique postures. . . ."

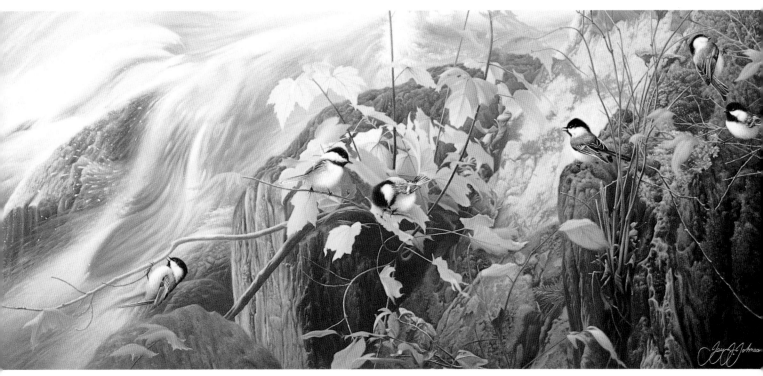

STEP 4

Finishing the Painting

"It's more interesting if a painting moves from a dark area to a light area rather than remaining homogeneous throughout. I'm aiming at going from very dark in the lower right corner to gradually lighter colors moving up and to the left. I've also made the bottom edge darker, which I feel adds weight to the bottom."

Caps and Bibs

For the chickadees' black caps and bibs, Johnson started by painting each area black, then working in the subtle lighter feather details wet-on-wet. Jay softened the black edges of the heads by (1) re-wetting the background (with paint saved in film canisters) and blending this with the wet black of the bird for a soft edge, or (2) mixing the background color with black on his palette and applying this on the edge for softness. Where the black-and-white marks meet, Jay preferred to blend wet. Jay uses refined linseed oil as a medium with his paint mixtures because it dries slowly enough to give him lots of blending time.

Bellies and Sides

For the chickadees' bellies, Johnson first paints in areas of white. A warmer color (including some Yellow Ochre and Naples Yellow) is used on the sides and flanks. Next, these two areas are blended together wet-on-wet using separate brushes for the white, the warm mixture and a mixture between the two. Once the transition is almost right, Jay uses a new, completely clean, soft brush to make the final blend better without adding additional paint.

Wings and Tails

For the wings and tails, Johnson starts with the dark tones, and when dry, paints in the lighter feather edges. Finally, he goes over each feather, blending the edges wet-on-wet. Most of the work on the chickadees was done using a no. 0 or no. 1 brush.

Warm Glazes

To finish the painting, Johnson warms the water with glazes of yellow and brown, softens the chickadees' feathers, and adds more texture to the rocks, while brightening up some spots on the rock on the right side. Finally, Johnson says, "I glazed some brighter orange/brown colors in the dead leaves," and "made the limbs stand out a bit more."

CHICKADEE FALLS
Jay J. Johnson, Oil, 14¼" × 34"

Suggesting Detail With Form

Savanna Sparrow *Bart Rulon* *Watercolor*

Looking for ideas in my slide files I came across a savanna sparrow singing from a cattail early one morning (photo 1). Additional elements would have to be added to make the composition better than in the photo. I also felt compelled to turn the sparrow's head slightly toward the viewer to make the gesture more interesting than a typical side view. The two out-of-focus cattails on the right had an interesting and useful placement that I wanted to utilize. Another photo (photo 2) was employed as a reference for shape and details. A third photo of a single cattail (photo 3) was used for the left side.

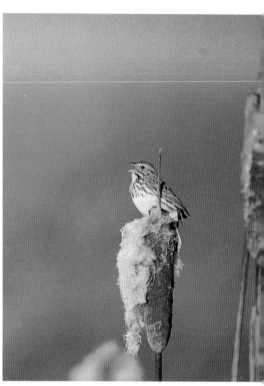

Photo 1

Photo 2

> ### Rulon's Watercolor Palette
> Lemon Yellow Hue, Yellow Ochre, Cadmium Orange, Raw Sienna, Burnt Sienna, Burnt Umber, Raw Umber, Payne's Gray, French Ultramarine, Winsor Blue, Cerulean Blue, Hooker's Green Dark, Alizarin Crimson, Cadmium Red, Permanent Rose

Photo 3

Thumbnail Sketches and Compositional Planning

These four thumbnail sketches plus two others helped me work out the final composition. I decided on the one at the far right. I felt the sparrow looked best toward the middle of the painting (proving that the compositional rule of avoiding the middle is not foolproof). I found it needed plenty of open space to the left and above where the sparrow was singing in order to look convincing.

STEP 1

Blocking in the Background

The drawing was transferred to watercolor paper. Step one was establishing some background color. I wanted to use a warm balance. Raw Sienna, Yellow Ochre and a little Cadmium Orange were mixed thoroughly with lots of water. The entire mixture on my palette was consistent so that wherever I put my brush into the puddle the intensity of color would be the same. A 1-inch flat watercolor brush was used for most of the large areas and a no. 12 watercolor round with a good point was used for the smaller shapes between cattails. To this point, I had applied about five washes of this water-laden mixture of paint. By using several washes to achieve this color, and not using a masking agent, the edges of the cattails are softened; each wash does not catch the edges in exactly the same way (thus creating a softness by accident).

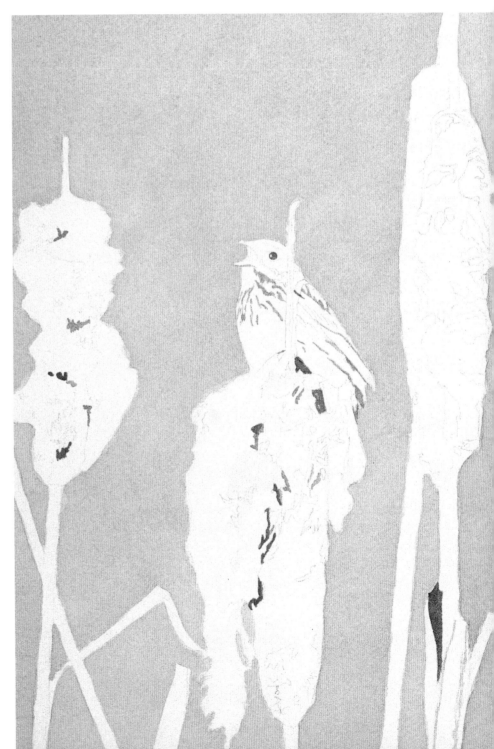

Beginning Cattails

Using Burnt Sienna and varying mixtures of Burnt Umber and Raw Sienna, I laid in a first wash on the middle cattail (using a no. 4 brush). Once dry, I used a more concentrated mixture of that same color to paint in the darker-colored details (using a no. 1 and no. 2 brush). I repeated this sequence of putting a wash on, then adding details, until the intensity was almost where I wanted it. I usually hold my final application of color until last, so that I can better compare it with the rest of the painting. Next, I worked on the other three cattails using the middle one as a color and shadow guide.

The fluffier areas on the cattails were started using a very thin and subtle blend of color. A watered-down version of the warm color used for the background is applied selectively to these light areas, indicating the warm morning sunlight.

Beginning Sparrow

I started to establish the sparrow's major markings, the eye and a few shadows. The areas that will eventually be quite dark (such as the dark streaks on the breast) are only painted in lightly now, so that I know where they are. If I were to paint them in too darkly from the start, my lighter washes might become tainted.

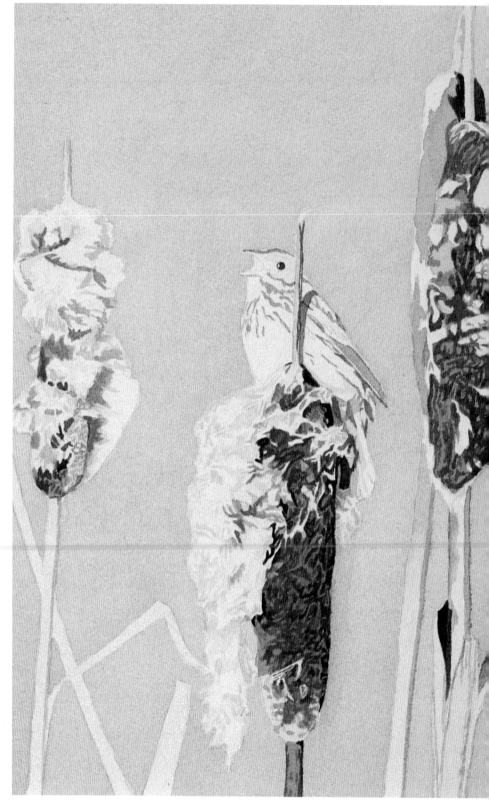

STEP 3

Background, Sparrow and Cattails

I started on the background using very watered down mixtures of green and a warm brown. Immediately after each area of color was applied, I rinsed the paint out of my brush and loaded it with water. I used this water to feather out the edges of each area, keeping a gradual mix of colors. I watched the wet areas closely until they dried, so that when a hard edge began to form I could quickly brush it out with water. Thin warm washes were applied to the bird's breast, belly and sides, indicating the warm morning sunlight. The same tactic was used on the lightest parts of the cattails.

Cattail Shadows

For the shadow areas of the cattails I used more intense mixtures of Burnt Sienna and Burnt Umber. This way, the color of the cattail in shadow stays warmer, truer to life. The stalk of each cattail is developed first by painting the shadowed edge and blending toward the middle. The stalk is often slightly darker immediately beneath the head.

Beak

The most important area on the sparrow is the opened beak. I approached it very carefully since my reference did not show me what it would look like at this angle. I started with thin mixtures of paint, working toward the edges of the beak until it looked correct.

Markings

I added thin, warm washes of Raw Sienna to the edges of many of the dark markings on the breast and sides. Some cooler washes of a French Ultramarine/ Alizarin Crimson mixture, indicate some of the feather edges. This mixture was also used (thicker) along the back edge of the bird for the shadow, and for the shadow cast by the top of the cattail. The yellow marking above the sparrow's eye is mostly Lemon Yellow Hue.

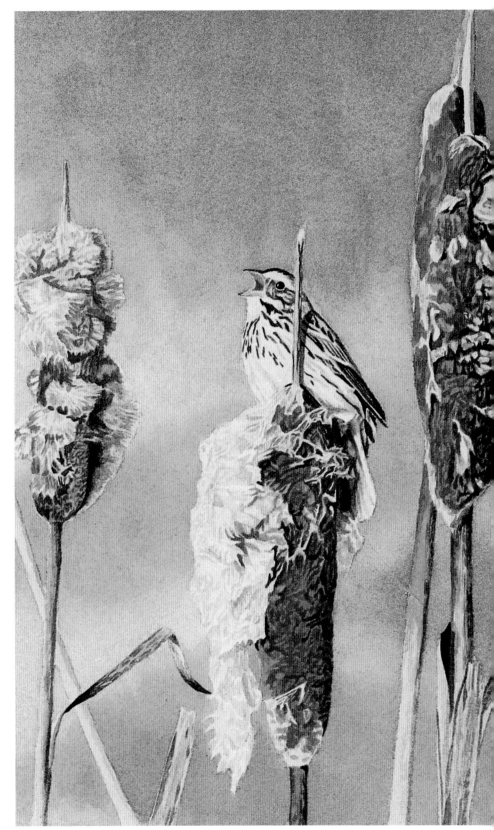

Establishing Color Intensity

The background was given several more washes to deepen the warmth, using a mixture of Burnt Sienna, Burnt Umber and Raw Sienna. The fluffy, light areas of the cattails received a few patchy washes of Raw Sienna to warm the color balance.

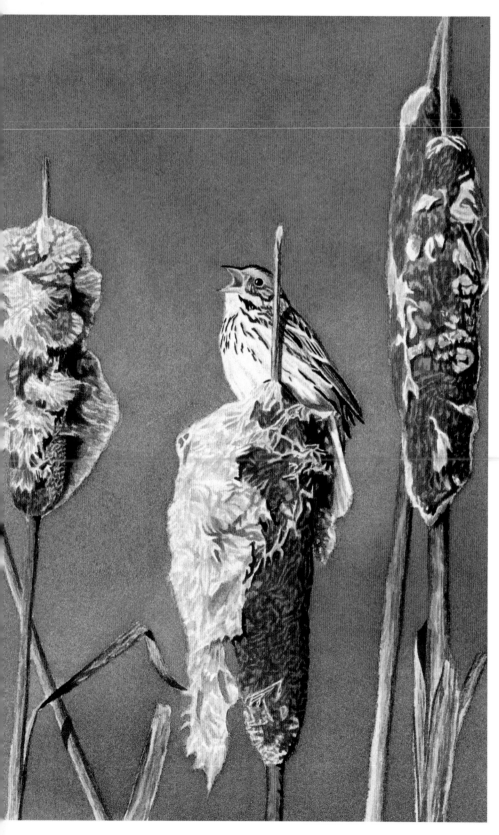

The sparrow was finished off with a light warm wash of Raw Sienna on the white underparts. The dark markings were given more contrast with one more layer of a Payne's Gray, Burnt Umber and French Ultramarine mix. The yellow streak of the eye was finished with thin washes of Raw Sienna, Cadmium Orange, Raw Umber and Lemon Yellow Hue on the bottom edge. Notice that the appearance of feathers was possible here without any detailed indications of each feather barb. The feather patterning, subtle colors from the lighting, and shape of the bird were the most important things for me to consider. Once these are done correctly, your eye does a pretty good job of filling in the minute details that are left out.

right

STEP 5

Critique and Finish

I noticed that something else was needed in the background to break up the somewhat uniform "1-2-3" arrangement of the cattails. The addition of three reeds cutting across the background would help solve this compositional problem by adding more diagonals and variety. They were added in a matter of minutes, mainly with a mixture of Raw Sienna and Titanium White acrylic paint. Some shadows and imperfections were added to the reeds by mixing Ultramarine Blue, Raw Umber and Cadmium Red Light Hue acrylic paint with the base mixture.

The reddish heads of the cattails were all darkened with total washes of Burnt Sienna, Burnt Umber and Raw Sienna. Then, with thicker versions of the same mixture, individual details were painted with a no. 1 watercolor brush. To keep some value variation, not all the details were darkened to the same extent. The shadows on the cattails were deepened with a thick mixture of Burnt Umber, Payne's Gray, French Ultramarine and Alizarin Crimson. Lastly, the sparrow got a few more warm washes on the breast and belly.

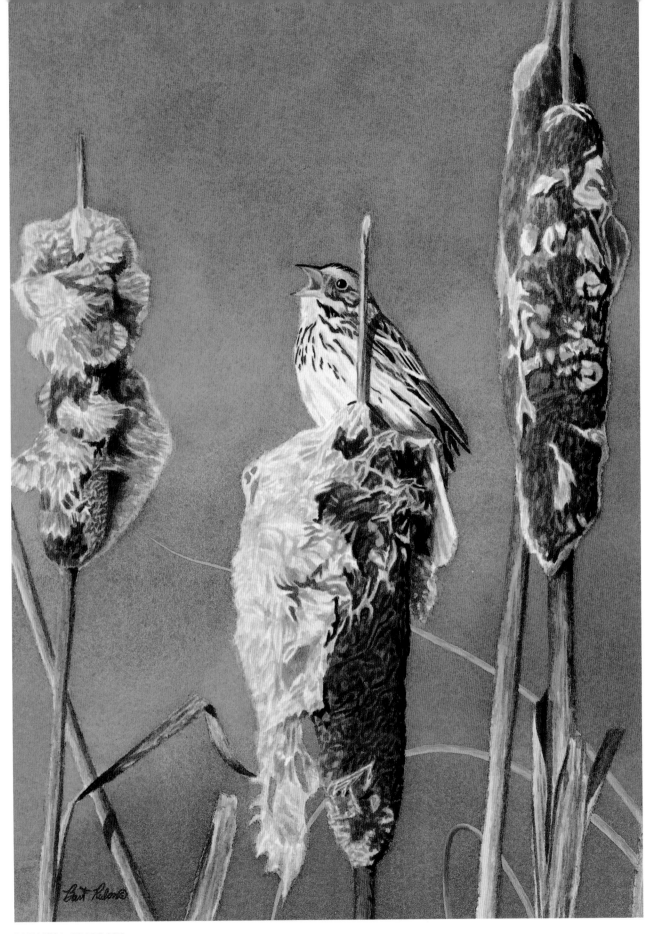

SAVANNA SPARROW
Bart Rulon, Watercolor, 9" × 13½"

Colored Pencil for Feather Texture

HORNBILL ✦ *Lindsay B. Scott* ✦ *Colored Pencil*

Lindsay B. Scott is well known for her skill in using colored pencil. Also proficient with oils, Scott bases her choice of medium for each work on the subject she wants to portray.

"Colored pencil . . ." says Scott, "beautifully captures the softness of birds' feathers."

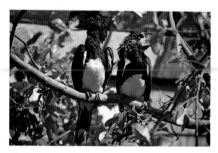

References
The two photos above show some of the references used for this piece.

Surface
"Choice of surface is very important," says Scott. For pencil she uses Crescent hot-pressed watercolor board. Its smoothness allows her complete control to create all kinds of textures. Rougher surfaces automatically cause textures by their very nature.

STEP 1

Thumbnail Sketch
"With colored pencil," says Scott, "planning is one of the most important steps." Here, she experimented with a toned background in the thumbnail sketch, but upon review decided against it for the actual piece. Next, Scott drew the bird full size onto tracing paper and then carefully transferred the outline drawing to her working surface by applying graphite to the back of the tracing paper, then gently drawing over just the most important lines.

STEP 2

Value Drawing

Next, Scott created a value drawing, working out details in lights and darks. She normally chooses a dark brown or gray pencil for this step. "I only use black as a color (such as tiger's stripes), not a value, as it is a very 'dead' color," says Scott.

The bird's head, especially the eye, is usually drawn first during this stage. "That is where the animal's character is," Scott says. "If I have captured that character, then I continue. Otherwise, I start over again."

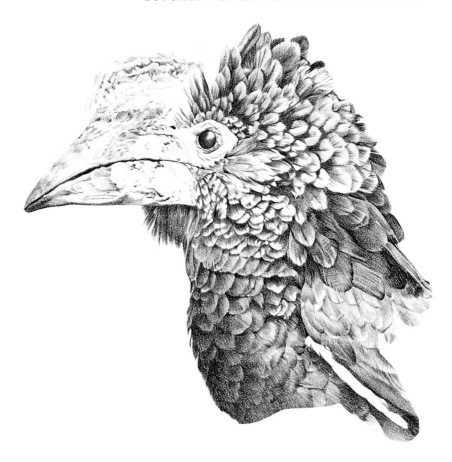

STEP 3

Introducing Color

After a reasonable portion of the value drawing is done, Scott starts laying in color. Here, with the hornbill, she applied a dark blue first then a dark gray or, for lighter areas, a pale gray. Scott says, "Always start with your darks . . . remembering that light values are achieved by using the whiteness of the paper."

Tips From the Pros

Scott uses Caran D'ache Supracolor I colored pencils. She says Supracolor I is "a hard colored pencil that gives off a lot of pigment. . . . Prismacolor and Derwent are more waxy and can be used for a more painterly look. It all depends on what result you want."

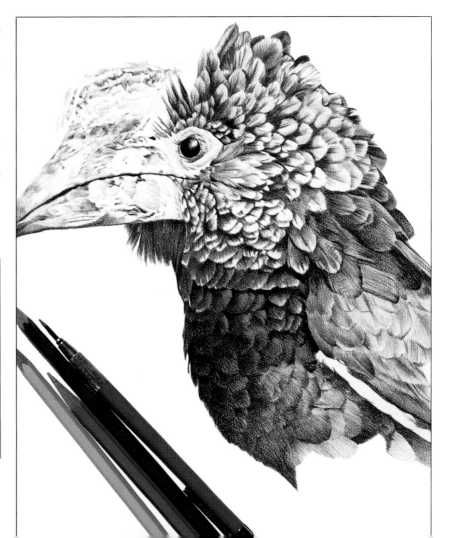

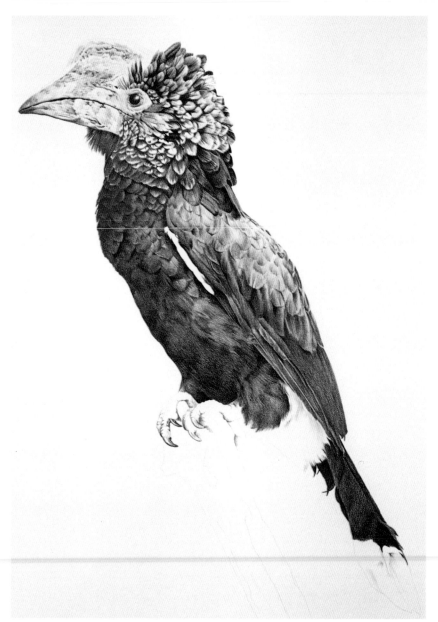

STEP 4

Filling Out Feathers

The dark areas are smoothed over or glazed with a dark or pale gray; this smoothes out the pigment and presses it into the paper rather than letting it sit on the surface. Once this has been done, another layer of pigment can be put over the top to get deep rich colors Keep layering color until the richness you want is achieved.

"For areas that are very bright white I sometimes use Pro White Opaque watercolor paint," says Scott. "It is a whiter white than the board, so it gives the drawing a little more life and dimension. All these small details are very important. It is a subtle medium, and the details must be taken care of. People will inspect the drawing very closely, unlike many oils that require viewing from a distance."

right

STEP 5

Finish

After a foundation of dark brown on the hornbill's beak, Scott added pale yellow, rose and gray. "My last step," she says, "is to glaze over the areas that I want to look smooth with a white pencil." Such was the case with the bird's beak in this painting.

Scott does not use any fixative spray over her pencil work because she's afraid this might have a yellowing effect over time. This requires that the artwork be handled very carefully to avoid smearing before it is framed under glass.

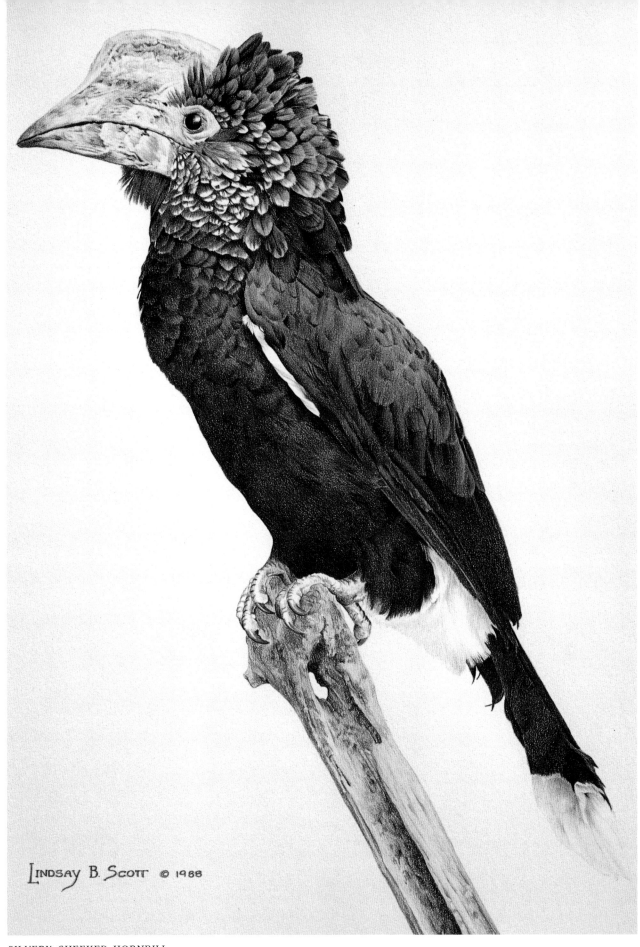

SILVERY CHEEKED HORNBILL
Lindsay B. Scott, Colored Pencil, 25" × 19"

Using Mixed Media

SNOWY OWL ✒ Sueellen Ross ✒ Pencil, India Ink, Watercolor and Acrylic

Sueellen's idea for including a snowy owl with Alaskan cotton came when she saw one at the Seattle Zoo on an overcast day. She says, "The top of the owl's head and shoulders glowed warm white. They reminded me of the cotton grass."

COMPOSITION

"I put the owl up front . . ." says Ross, "because I didn't want its impact lessened by being just another round mass of white, mostly buried in the grasses. In this composition, he appears to be slightly above ground level—on a stone, or a mound of earth. His gaze is focused somewhere beyond the viewer. He is relaxed, but he dominates the scene." Ross then designed the rest of the painting around the bird directly on her watercolor paper without using any thumbnail sketches. She wanted to use a zig-zag pattern of Alaskan cotton trailing back from the owl into the background.

PAINTING SURFACE

"Lately I've been using a 140 lb. Hot-pressed paper," says Ross, "either Lanaquerelle or Arches—which allows me to do detailed Rapidograph work without bleeding or catching the point of the pen. I like the way the hard surface of the paper makes the watercolors pool and settle as they dry. The colors seem brighter on this hard surface, and my ultimate colored-pencil work retains a crisp edge."

STEP 1

Pencil, India Ink
Sueellen Ross's mixed media technique evolved from her etchings, where, she says, "the design is absolute and complete at the pencil stage, and *line* is king (or queen)." Ross's first step is to do a very complete and detailed drawing. She says, "The preliminary sketch takes more time than any other stage. Absolutely everything must be down on paper before I can do anything else." She starts this drawing with a soft pencil, then goes over the final lines with a hard no. 4 pencil, which actually etches deeply into the paper.

Once her pencil drawing is complete, the next step is to lay in the darkest values with India ink. "I always go from dark to light, and I always go to India ink from a graphite pencil," says Ross. "Even the smallest areas go in, and each black area is outlined with a Rapidograph pen for precision, then filled in with a brush. When I go to India ink, the lines of my drawing are still visible. In fact, my 'engraving' remains visible until the final step, which is Prismacolor pencil."

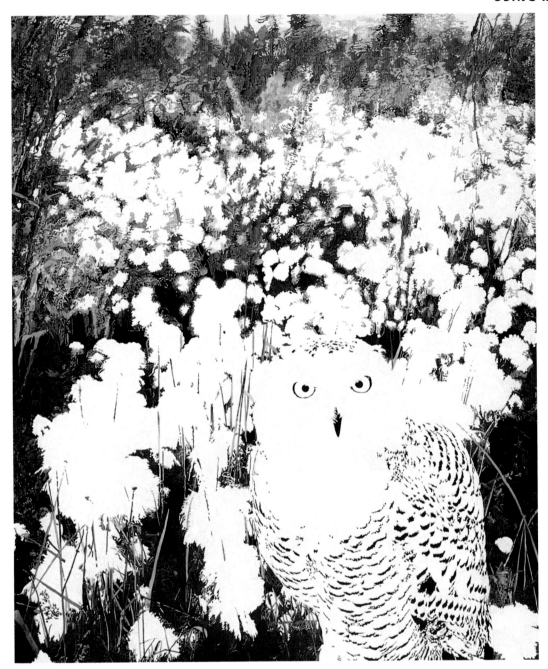

STEP 2

Paint

Before proceeding, Ross masks areas that she wants to remain white. "The sky is the first color to go in," says Ross, "a light watercolor wash of . . . Payne's Gray, punched up with Manganese Blue at the misty horizon." Next, she paints in many of the darkly colored areas in the background and foreground with dark watercolor. "I go over the India ink areas with dark watercolor as I go along. This cuts the glare of the ink and allows me to work over it with pencil later." For her watercolor work, Ross generally uses a no. 3 or no. 4 Winsor & Newton series 239 brush, using larger sizes for areas requiring bigger washes.

Each color is applied individually to her drawing. Blending will occur later by using colored pencil or wetting dry edges with a brush and scrubbing.

At this point, most of the background is in, except for the white flowers. As a final part of this step, Ross tones down some of the brightest colors with Raw Umber Violet. Now she is ready to turn her attention to the flowers and the owl.

Ross's Dark
Watercolor Palette
Burnt Umber, Warm Sepia, Sepia, Charcoal Gray, Neutral Tint
Mixtures: Gamboge + Burnt Sienna, Cadmium Yellow + Sap Green + Compose Green, Alizarin Crimson + Warm Sepia, Violet + Raw Umber, Yellow Ochre + Raw Umber, Hooker's Green Dark + Warm Sepia, Hooker's Green Dark + Warm Sepia + Compose Green No. 3

Owl, Flowers, Foliage

A pale wash of Warm Gray Winsor & Newton Liquid Acrylic is applied over all the white areas, followed by darker washes in darker areas. Ross says, "On the flowers and the owl, I add a final, diluted wash of Winsor & Newton Burnt Umber over the grays to warm them. The bird's eyes get Daniel Smith's Quinacridone Gold (as a main color) and Burnt Orange (for shading)—both are brilliant, transparent colors." Where there are harsh edges between values, Ross blends them by scrubbing the dry paint with a wet brush and then using a Kleenex to pick up excess color.

Using Colored Pencils

Next, Ross begins using colored pencils. During this last portion of her painting, she is not looking at her references too much, but rather concentrating on how to make everything work together.

Finishing the Owl

Ross finishes the owl first. She highlights its bill with white. Darks are then penciled in on the tops of the eyes, for a shadow effect, using black and Dark Umber. The brightest highlights in the eyes are added with white gouache. Then Ross adds dimension to the whites and grays with Raw Umber, Sepia, Dark Umber and black pencil, blending them with white and Warm Light Gray. The "engraving" line still re-mains, indicating her feather edges. To blend out from darker pencil colors, lighter colors are blended into them. Shadows on the white bird are Raw Umber (for warmer areas) and Sepia (for cooler areas). Lastly, the owl's color was warmed up by blending in Cream, Sand and Derwent's Brown Ochre. For softer areas, Ross will let pencils get dull as she uses them.

Background Foliage

Feeling that background foliage was too harsh, Ross misted water over the painting, picking up excess water with tissues, then penciled in jewel tones using Yellow Ochre, Olive Green, Burnt Ochre and Tuscan Red. Dulled black pencil was then carefully applied to avoid distinct pencil marks. Ross also used her fingers, tissues and Q-Tips to spread out this layer of black pencil, and finally used a paper towel to polish it.

Background Flowers

In order to make background flowers recede, Ross softened the edges with Sepia and Raw Umber, blending Warm Gray and white pencil into the dark colors, and then highlighting all the flowers using Cream and Sand. Ross says, "The cotton grass is the same white as the owl, and fades in brilliance as it recedes into the background. Only occasional highlights in the background approach this white, so the eye focuses on the foreground." Ross says, "Every color in the background—the evergreens, shrubs, fall foliage and green grasses—is repeated in the foreground." Bright Vermilion, Canary Yellow and Sand were added in spots spread around the foreground to echo the brilliance of the bird's eyes. "All of the colors in the background are found on the bird, except Olive Green, so that every area of the painting relates to every other area." Finally, Ross says, "a couple of bright spots are added to the grasses with scarlet and orange pencil. . . ."

Middle-Ground Colored Pencil Palette

Red Shrubs, Bushes, Grasses: Tuscan Red, Burnt Ochre, Dark Umber
Green Vegetation: Olive (blending), Limepeel (brightening), Black (softening edges between ink and green watercolor)

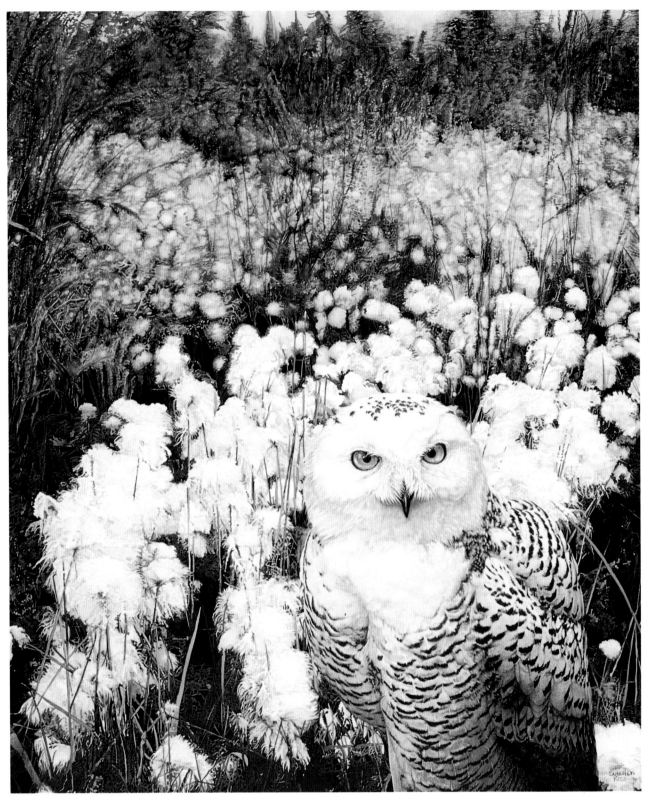

ALASKAN COTTON, SNOWY OWL
*Sueellen Ross, Mixed media—India ink,
watercolor, acrylic and colored pencil on Arches
paper, 23"×27"*

Painting Complex Feather Patterns

Ruffed Grouse ✒ *Paco Young* ✒ *Acrylic*

Paco Young generally prefers to depict his subjects blending in with their environment rather than standing out. "Winter Pair—Ruffed Grouse" is an exception to this preference. "The contrast of the ruffed grouse to the snow, warm colors against cool, intrigued me," says Young. "I find it a challenge to paint in this strong, warm light. In fact, this piece began as a concept of birds walking on deep snow with dark, snow-covered conifers as a backdrop—I then went about compiling the proper reference to fulfill my vision of the painting."

SKETCHES AND PLANNING

Paco Young usually works his painting ideas out in the form of thumbnail sketches. However, he says, "Most often I find that a lot of preplanning yields a boring painting. I like for my work to be a bit spontaneous. I think this makes the work more exciting and interesting from the beginning."

Gesso Prepared Panel
Paco first primes his untempered Masonite panel with three coats of unthinned gesso, sanding lightly between coats. This smooth, evenly textured surface best portrays snow. To achieve this he uses a very smooth finish roller, rather than a brush, to apply the gesso.

Young's Acrylic Palette
Cadmium Yellow Light, Cadmium Yellow Medium, Naples Yellow, Cadmium Orange, Cadmium Red Light or Medium, Alizarin Crimson, Portrait Pink, Ultramarine Blue, Cobalt Blue, Phthalo Blue, Violet, Burnt Sienna, Burnt Umber, Yellow Ochre, Raw Sienna, Payne's Gray

Young prefers white gesso over Titanium White because it mixes better for a matte finish and accepts glazes very well. He combines Burnt Umber and Ultramarine Blue to make black.

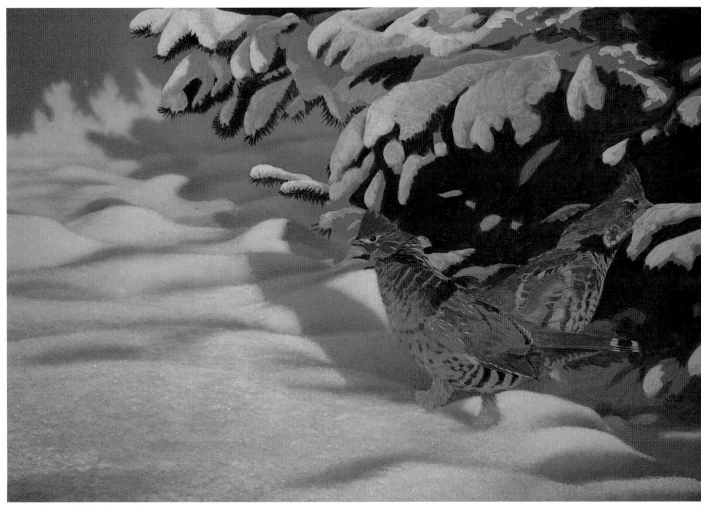

STEP 1

Blocking In

"I began with a blue-violet ground color since the piece would have . . . an all-around blue shadow cast." Young then loosely sketched in his drawing with a white pencil, yielding faint lines.

Planning and Establishing Contrast

Young knew that this painting would feature strong lighting and extreme contrasts. His first priority was to build these elements by "blocking in" light and dark areas first. "It is at this point that you should have a good idea of the overall look of the piece," says Young. "The composition and value relationships should be correct and, hopefully, interesting." Young's plan for this painting was first to bring the background snow and trees to near completion, then to work on the birds, and lastly, to make minor adjustments and finishing touches. His snow was painted working dark to light with glazes of a warm light mixture of gesso, Yellow Ochre and Light Portrait Pink. The Portrait Pink helps keep the snow from taking on a greenish look against the blue shadows.

Young's Brushes

- Flat sizes nos. 2, 4, 6 and 8 do much of the painting work.
- A Robert Simmons 1-inch Skyflow Wash no. 278 is used for broad coverage and blending.
- Winsor & Newton University Gold rounds nos. 1, 2, 4, 6, 12 and 18 are used for details such as feathers and tree limbs.
- A Scharff 3000 no. 3 or a Grumbacher Golden Eagle 4623 no. 2 are used sparingly for just the very finest details.

STEP 2

Establishing Lights and Darks

Young says, "Feather groups and basic anatomy are blocked in. I work loosely at first, and then constantly correct and tighten the brushstrokes." He does most of this early feather rendering with one of his flat brushes, using the flat surface for larger feathers, and using one of the brushes' corner tips to rough in the smaller feathers. Young says, "I use the flat brushes for most of my painting as they are quite versatile—you can use the broad side of the brush for larger strokes or use the sharp edges for clean, straight lines—excellent for blades of grass."

STEP 3

The Eyes

Young normally finishes the eyes first. As he says, "This gives an immediate sense of life. I paint the overall eye color first: brown, yellow, etc. Then the pupil is painted. Once the eye shape and structure is complete, I will paint a soft light on top of the eyeball (depending on the direction of the prevailing light source) and will make certain that this is soft on the edges and contours. Then I will apply the smallest dot of white on this area to create the sharp sparkle of a wet globe. Finally, refracted or reflected light is applied under the pupil. This must be a lighter, cleaner version of the iris color. For example, a brown iris will often have a refracted light color of Raw Sienna or Burnt Sienna." Lastly, he paints the eyelids and shapes the outside structure of the eyes.

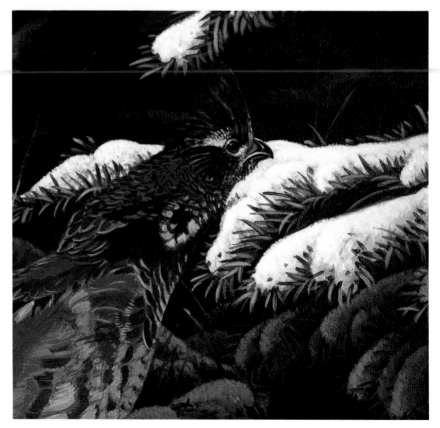

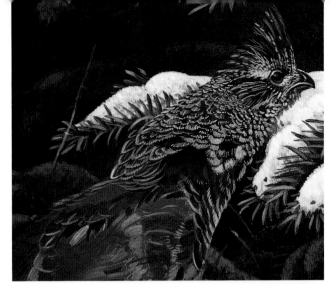

Painting Feather Details

Thin layers of light color are added on top of previously established darks on heads and necks. "Because these birds are so mottled with patterns, I work in small areas, feather groups." The feather edges were first underpainted with a yellow/white mixture for the grouse on the right. Round brushes, nos. 2 or 1, are used for this more detailed work. Young uses the tip of the brush for each stroke rather than spreading the tips out for a feathered effect.

Alternating between layers of light and dark to develop the feathers, Young next glazes the light feathers with a warm Yellow Ochre/Raw Sienna mixture. Then, from there, he brings some of the appropriate feather edges back toward a lighter color by simply adding more glazes on top of the already-positioned feathers. Notice the depth created in the head and neck areas with this layer-upon-layer approach. With feathers, using acrylics, Paco almost always uses this glaze-upon-glaze approach, and he will keep glazing back and forth until satisfied with the results.

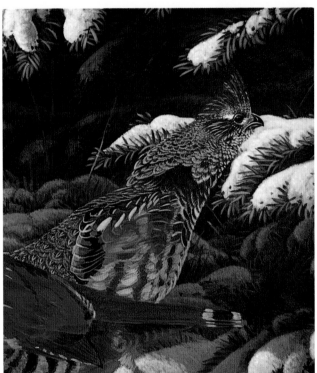

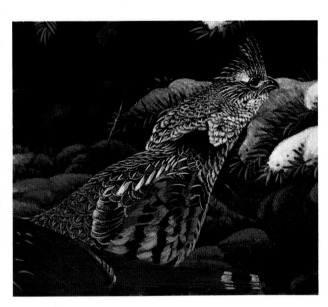

Tips From the Pros

"I use a technique of underpainting and glazing. I like to be able to build one pure color on top of another. . . . For example, in a shadow area that may have a blue cast, instead of mixing, say, Cobalt and Payne's Gray and applying it, I may do one layer of Cobalt, allow it to dry, glaze with the Payne's and then repeat the process. This keeps the colors clean and allows you to glaze warm over cool or any complementary over another. And by underpainting, you can complete the bird feathers or any other part of the bird and then glaze shadow areas or intensify local color."

—*Paco Young*

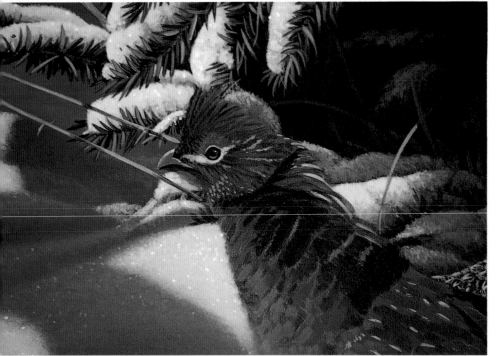

Underpainting to Finished Feathers

Value relationships, eyes and feather details for the left grouse are developed using the same glaze procedure. Notice how much of the initial underpainting shows through.

"With birds you must be aware of the difference in texture among individual feathers and feather groups," says Young. "For instance, flight feathers on the wings are stiff and have a hard finish. Covert and breast feathers are soft and downy, and should be painted more like fur (although not usually as bristly or hair-like), with soft dry-brushing or soft-edged glazes. Flight feathers, conversely, have a more reflective surface with light and dark edges." Here you can see the transition of underpainting to finished feathers on belly, flanks and wing.

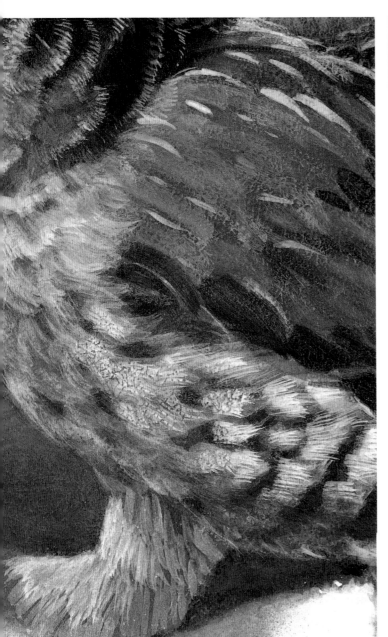

Details of Grouse on Left

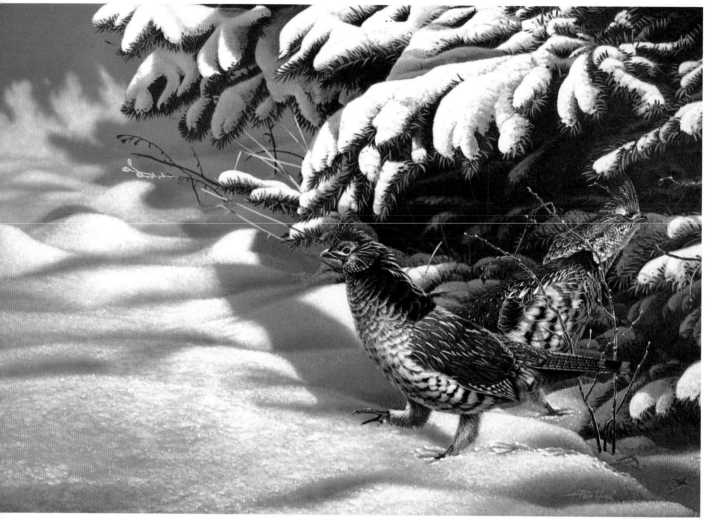

STEP 6

Finishing Corrections

Finally, Young felt that the right grouse was not working too well, so he glazed both birds with a warm red mixture of Burnt Umber, Burnt Sienna and Raw Sienna, using one of his flat brushes. Afterwards, he noticed that some of the feather edges looked too stiff and would require more softening. To alleviate this problem, partly caused by contrast between feather patterns, he gave the breast feathers a wash of a light-colored mixture, and then a dark wash was given to the other, darker areas of the bird, such as the back and wing. These washes effectively cut down the contrast between dark and light markings and resulted in softer-looking feathers.

"Knowing when a painting is finished can be a difficult task," says Young. "There comes a point in the painting when you must ask yourself, 'If I add anything else, any more detail, will the piece be better, or will it just be more detailed?' When the subject looks real and correct to me, the painting is complete." Young's final step is two or three coats of acrylic spray varnish. The first layer is a gloss varnish, followed by a matte varnish. He says, "I think the gloss helps to consolidate the image and pulls out the darks, but since I prefer a matte finish on my work, I give it one or two matte coats."

WINTER PAIR
(*Ruffed grouse*)
Paco Young, Acrylic on masonite, 20" × 30"

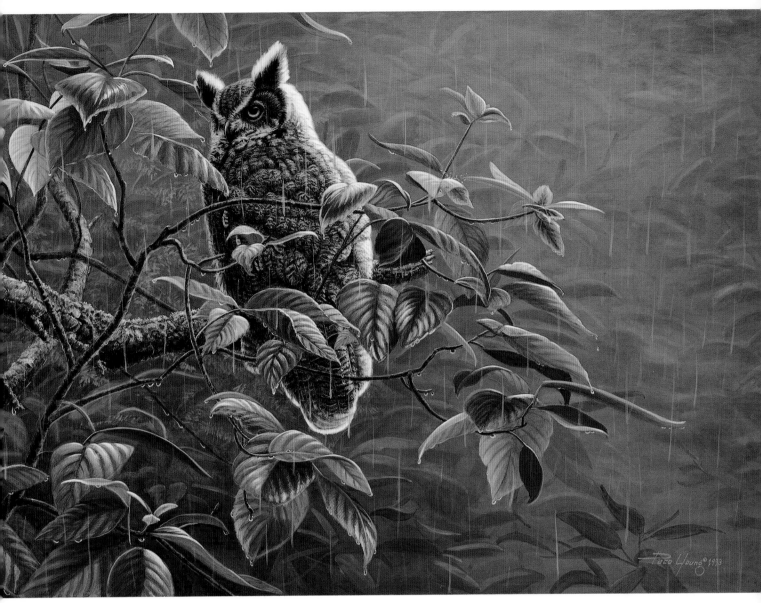

SUMMER RAIN
Paco Young, Acrylic, 20" × 29"

IMPORTANT TIPS AND TECHNIQUES

BOG PATTERNS
(Snipe)
Thomas Quinn, Gouache and Acrylic, 25" × 38"

The Skeleton

Understanding the skeletal framework of birds will give you a big advantage in your drawing. The skeleton of a bird is strong and light, with hollow bones supported by a honeycomb-like system inside them.

Notice how many neck vertebrae there are, to allow for flexibility. Next, notice how the wing attaches to the shoulder, and how the wing bones compare to the human arm and hand. Birds of flight have an enlarged breastbone for the attachment of large flight muscles.

It helps to compare the feet and leg bones with those of a human. Most birds actually stand on their toes. What you might call a leg, from the toes to the next joint, actually corresponds to the human foot, from the toes to the heel. This is called the tarsometatarsus, which leads to the heel. Above the heel is the knee joint, which is actually hidden from view by the feathers and skin. Part of the tibiotarsus, the bone leading up to the knee, can usually be seen externally on a bird (this is the same bone that bears the "drumstick" on a chicken). The next bone up is the femur, or the thigh bone, which is not externally visible.

Birds have reduced tailbones, and a fusion of the backbone and pelvis. The tailbone is short on a bird, but its vertebrae allow for movement of the tail. The last vertebral bone, the pygostyle, carries the tail feathers.

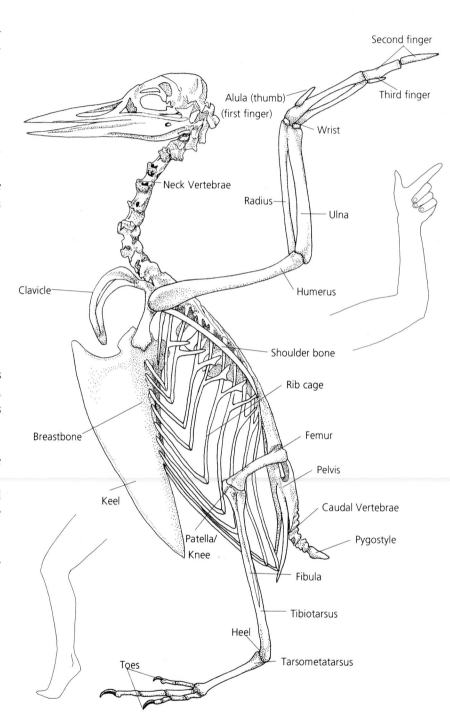

Bird Skeleton
Compare the bird's leg and wing bones with that of the human leg and arm to understand how they work. Also notice the large breastbone, which anchors the flight muscles.

External Structure

Knowing the external anatomy of a bird will help you to understand other parts of this book where specific body parts are mentioned. It will also allow you to become more familiar with the terminology that is used in bird field guides, books and discussions about birds that may be important to depicting a bird accurately.

Stellar's Jay

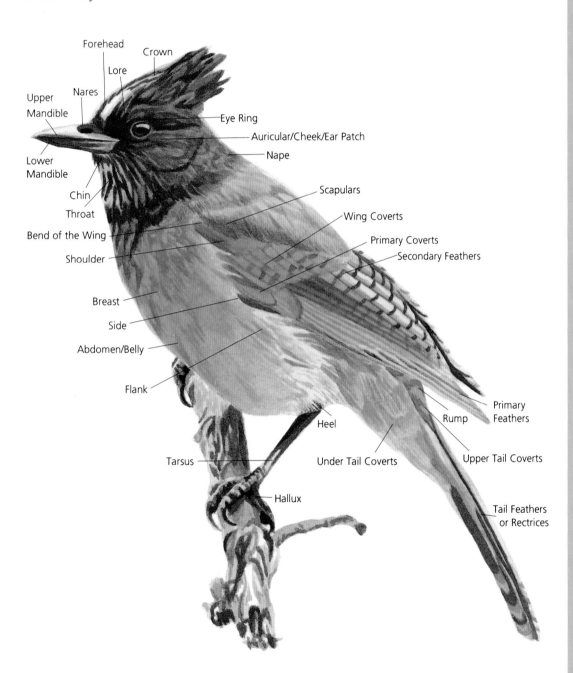

Forehead

Crown

Lore

Nares

Upper Mandible

Lower Mandible

Eye Ring

Auricular/Cheek/Ear Patch

Nape

Chin

Throat

Bend of the Wing

Shoulder

Scapulars

Wing Coverts

Primary Coverts

Secondary Feathers

Breast

Side

Abdomen/Belly

Flank

Heel

Tarsus

Under Tail Coverts

Rump

Primary Feathers

Upper Tail Coverts

Hallux

Tail Feathers or Rectrices

Feathers

Primary flight feathers, their coverts and tail feathers are of a definite number for each species. In general, the number of primary flight feathers ranges from nine to eleven. Secondary flight feathers usually range from six to twenty-four, but some birds have more, such as the albatross. Tail feathers can range anywhere from eight to twenty-four in number.

Most of the songbirds (passerines), have nine or ten primaries, nine secondaries and twelve tail feathers. Waterfowl have ten primaries plus one vestigial primary (a very greatly reduced primary not often visible), fifteen to twenty-four secondaries, and tail feather numbers from twelve to eighteen in ducks, fourteen to twenty in geese, and twenty to twenty-four in swans, all depending on the species. Owls have ten normal primaries (normal meaning not vestigial), eleven to eighteen secondaries, and most have twelve tail feathers. Hawks, eagles and falcons have ten normal primaries and twelve to fourteen tail feathers. Some of these birds have one vestigial primary on each wing that is very small, and usually not visible, so I have not included them in the feather count. Keep in mind that this is only a general guide. The best way to be sure about the number of feathers for a specific species is to refer to a study skin, a reliable close-up photograph, or specific information on that species.

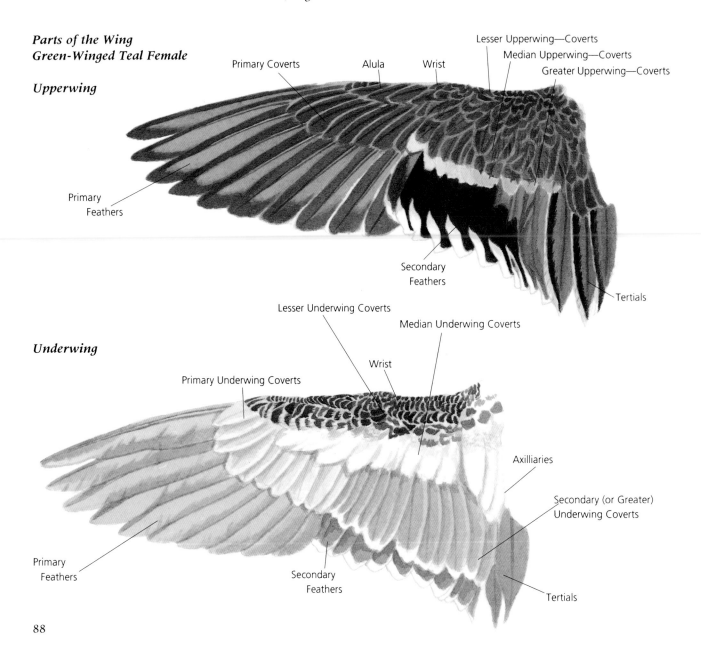

Parts of the Wing
Green-Winged Teal Female

Upperwing

Primary Coverts · Alula · Wrist · Lesser Upperwing—Coverts · Median Upperwing—Coverts · Greater Upperwing—Coverts · Primary Feathers · Secondary Feathers · Tertials

Underwing

Lesser Underwing Coverts · Median Underwing Coverts · Wrist · Primary Underwing Coverts · Axilliaries · Secondary (or Greater) Underwing Coverts · Primary Feathers · Secondary Feathers · Tertials

88

The Wing

The wing is best explained in relation to a human arm and hand. Working outward from the shoulder, the first bone is the humerus. It relates to the section between our shoulder and elbow. The humerus is usually short, especially in birds with quick wingbeats, but it is longer in birds that glide. The radius and the ulna are equivalent to the human forearm. The ulna provides the attachment for all the secondary flight feathers. The next joint is the wrist, and then the fingers, which are formed as if all the fingers of a human hand were closed except for the index finger, which extends out the farthest on a bird's wing. These fingers form the attachment for all the primary flight feathers.

MECHANICS OF THE WING

To open its wings, a bird pushes the humerus out, opening the elbow joint. With this action, the wrist is automatically pulled forward, opening up the primary flight feathers. Full extension is stopped by a tendon running from the wrist to the shoulder, which makes up the leading edge of the wing (an important thing to realize when depicting birds in flight). Even when the wing is fully extended, the elbow is still bent inside it. Since the leading edge, between the shoulder and wrist, is formed by a tendon, it can be curved, when the wing is partially bent, or straight, from the tension of an extended wing.

A ligament running from the second finger to the elbow attaches to the bases of all the primary and secondary feathers. When the wing is opened, the flight feathers are placed in position by this stretched ligament, called the vinculum.

How Feathers Are Attached
Notice how the tendon running from shoulder to wrist forms the leading edge of the bird's spread wing. Primaries stem from the fingers beyond the wrist, and secondaries stem from the ulna between the wrist and elbow.

How Birds Fly

Understanding the basics of flight helps in your ability to depict flying birds correctly. Wings beat forward and down on the downstroke, and backward and up on the upstroke. The inner wing, from the shoulder to the wrist, bearing the secondary and tertial flight feathers, does not move forward and backward as much as the outer wing does during a flight sequence. The inner wing beats within a tighter margin, providing most of the lift. The outer wing provides most of the forward thrust for the bird in flight.

Starting with the upstroke, the bird lifts its wrists, and the outer wings fold partially, closing the primaries like a fan, thus reducing the resistance as the wing raises. To further battle resistance, the primaries rotate slightly and separate, allowing air to pass through them, then fold as they are lifted up, rotating backward. At the end of the upstroke, the outer wing flips up quickly as the primaries unfold to increase surface area for the down-stroke. For the downstroke, the primaries of the outer wing are pulled down and forward by the wrist. The wing's leading edge is lower than the trailing edge, providing forward thrust.

The more precise details of wing-beat cycles are extremely complex, and can vary between species. This is only meant as a simple guide to help you avoid mistakes when depicting birds in flight.

Upstroke

Beginning of upstroke

Wing tip swept back

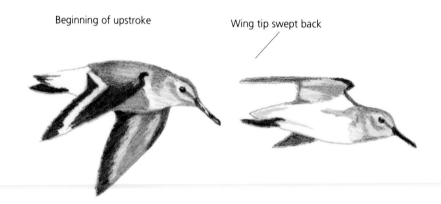

The Wingbeat Cycle
Notice in this approximate sequence of one full wingbeat that the wing rotates forward on the downstroke and backward on the upstroke.

Downstroke

Beginning of downstroke

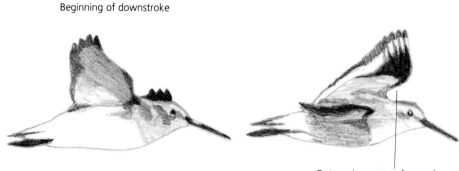

Outer wing comes forward

Range of Movement
Wrist movement compared to that of the wing tip during a wingbeat is different in magnitude. Both move forward on the downstroke and backward on the upstroke, but the wing tip does so with a much greater radius.

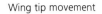
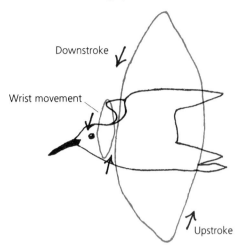

Wing tip movement

Downstroke

Wrist movement

Upstroke

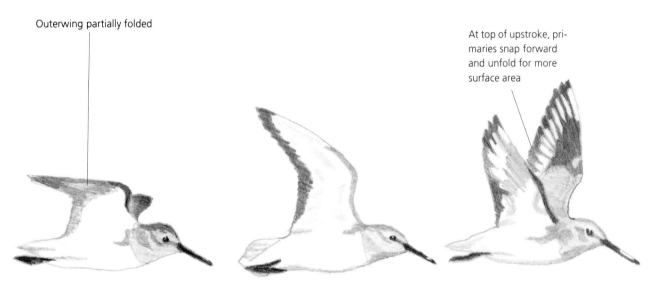

Outerwing partially folded

At top of upstroke, primaries snap forward and unfold for more surface area

End of upstroke

End of downstroke

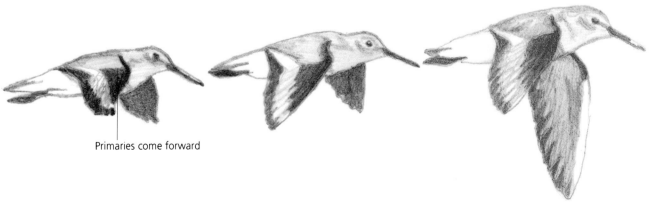

Primaries come forward

GLIDING

Birds glide slowly by fully spreading their wings. To speed up, a gliding bird will fold its wings at the wrist, folding the primaries and reducing the wing's surface area. This can be seen, for example, when a peregrine falcon, in order to gain speed without flapping, begins a dive for prey.

THE ALULA

This part of the wing, the equivalent of our thumb, may look useless, but it plays a role in bird flight, especially at slow speeds. When hovering, landing, or flying at a high angle of attack, the alula is often automatically raised by air pressure to keep a bird from stalling. The alula reduces turbulence by causing a stream of air to be forced along the upper edge of the wing.

THE TAIL

The tail is a very important part of a bird's flight. It can be raised, lowered, twisted sideways, fanned out and closed down to help in steering, adding extra lift, and braking. It is most often seen fully fanned out during takeoff, landing and gliding. Some birds, such as puffins and diving ducks, also drag their feet to add more control when landing and to help add more lift when taking off.

LANDING

For many birds, the approach to a landing may begin with gliding, where wings and body tilt back, ending the landing in a rush of wingbeats. During this moment, the body will be almost vertical. Inner wings are at a very high angle of attack (more vertical), but outer wings are positioned with less angle of attack (more horizontal). The inner wing slows the bird down the most, while the outer wing generates lift, which allows the bird to be almost hovering the instant before landing.

Wing Cross Section

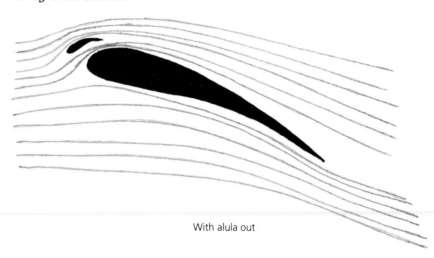

With alula out

How the Alula Works
At a certain angle of attack, the alula is automatically opened to force a stream of air against the back of a bird's wing to help prevent stalling.

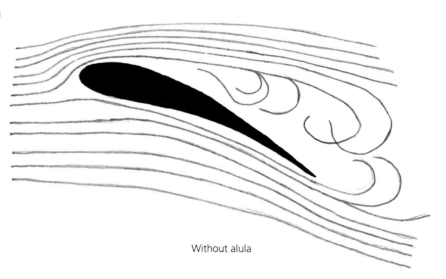

Without alula

92

INTO THE MIST
(Bald eagle)
Terry Isaac, Acrylic on Masonite, 24" × 40"

Wing Tips

Here a bald eagle soars slowly with its wings fully spread. The primary flight feathers of many birds are narrowed in width near the tip. When the wing is spread out, as shown, the tip separates with gaps between the primaries. These separated feathers can twist in the air to help make low speed flight such as gliding more effective. They may also help the bird avoid stalling at slow speeds. Birds with more rounded or relatively short wings tend to have more obvious gaps in their wings than those with relatively slimmer pointed wings such as swallows or falcons where there may only be one gap.

Gripping a Branch

You might think that birds apply a death grip to everything they land on, but this is not true. Depending on the diameter of the branch or other object, the feet often have a rather relaxed grip. Balance is important to a bird staying on a branch, as well as its grip. Much of the bottom surface area of the toes may not even be touching on a small branch or object. When a bird hangs upside-down, the toes will be in contact, but the base of the foot might not even touch the branch.

When a bird lands on a vertical branch, the lower foot and leg, which support most of the weight, will often display a consistent toe arrangement. The two bottom front toes will usually be positioned together, while the other front toe grips farther up. The lowermost leg is always placed at an angle downward from the body to support weight. In this situation, the other leg (higher on the vertical branch) keeps the bird from falling sideways, and will often have a looser grip. The upper leg will have a more perpendicular angle on the vertical branch than the lower leg does.

STUDY FEET

Get into the habit of looking at bird feet in different situations. Take advantage of being able to see captive birds up close. Do several sketches or take photographs of feet in different positions. The more time you spend studying feet, the more you will understand how they look and function.

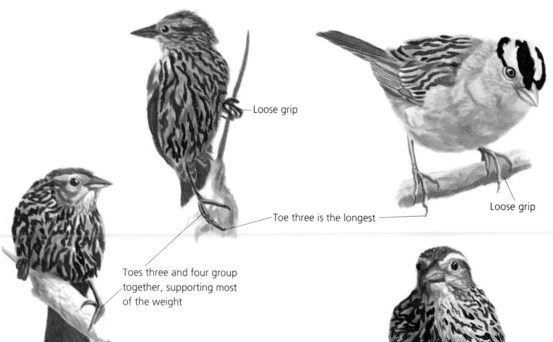

Loose grip

Toe three is the longest

Toes three and four group together, supporting most of the weight

Loose grip

Toes grip more tightly due to branch size and tension of alarmed bird

Various Grips

Much depends on branch size and bird type. Notice that the two birds at left display the third and fourth toe on the lowest foot close together for support. The uppermost toes of the bird at top left are loosely gripped to the top of the cattail, partly because of the size of the stem, and because the function of that foot in gripping is different from the lower foot. Now compare the grips on the right side. The white-crowned sparrow's grip (upper right) is rather loose, and more on top of the branch, whereas the blackbird's grip looks tighter, probably because of the size of the branch, as well as the fact that the bird is somewhat off balance, alarmed and poised to fly.

GOLD ON THE ROSE
(American goldfinch)
Terry Isaac, Acrylic, 18" × 24"
Artwork courtesy of Terry Isaac, copyright 1988,
and Mill Pond Press, Inc., Venice, Florida 34292.

Toe Arrangement

Notice the toes of the lowest foot on the two male goldfinches depicted in this painting. Two of the front toes, toe three and toe four, are bunched together for supporting the weight when these birds are on a diagonal branch. The second toe is separated from the others. Also notice how apparently loose the toes in this painting are gripping their respective branches.

Rule of Thirds

The rule of thirds states that if you dissect a picture with three equally spaced horizontal and vertical lines forming a grid, and place the subject somewhere touching one or more of the outermost lines, you will end up with a pleasing design. Basically, avoid the middle, creating a bull's-eye effect.

Rule of Thirds
Divide picture using two sets of three equally spaced lines, as shown. Place focal point near outermost lines.

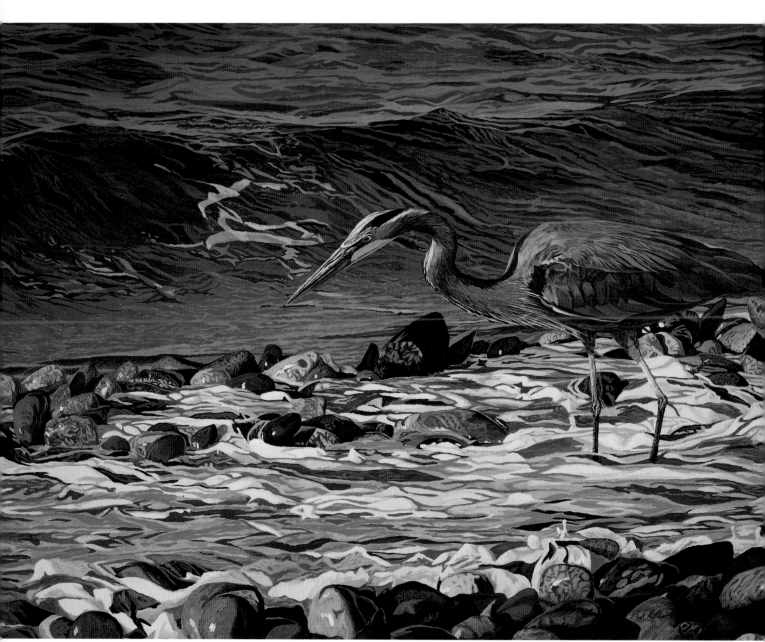

BEFORE THE WAVE BREAKS
(Great blue heron), Bart Rulon, Acrylic, 30"×40"

Breaking the Rule

The rule of thirds is a good rule of thumb, but don't take it as an unbreakable law. There are times when placement near the center or in an unusual position might be the best solution. When it comes right down to it, trust your instincts.

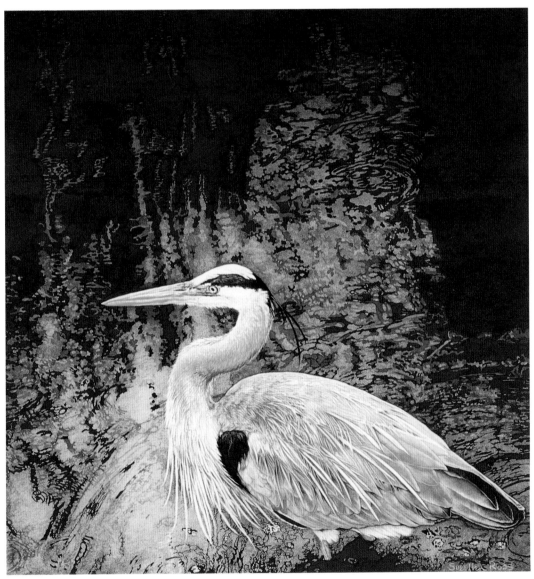

GREAT BLUE
Sueellen Ross, India ink, colored pencil, watercolor, and acrylic on Arches paper, 16" × 14"

Unique Placement
Don't be afraid to try compositional ideas that are different from what you normally see. In this painting, placement of the great blue heron toward the bottom helps draw attention to the interesting reflections in the water behind the subject.

Looking Out vs. Looking In

When painting a bird in motion, allow space in front of it, to absorb its visual momentum. Deciding on whether a resting bird should be looking into the painting or outward is not as simple. Placing a bird on one side of a piece looking inward will lead the eye toward other elements in your painting. Placing a bird on one side, looking out of that same side, creates visual curiosity about what lies beyond the artwork's borders. You can really draw attention to the main subject this way. Curiosity about what the bird is looking at will perhaps prompt a reexamination of the rest of the painting for visual clues.

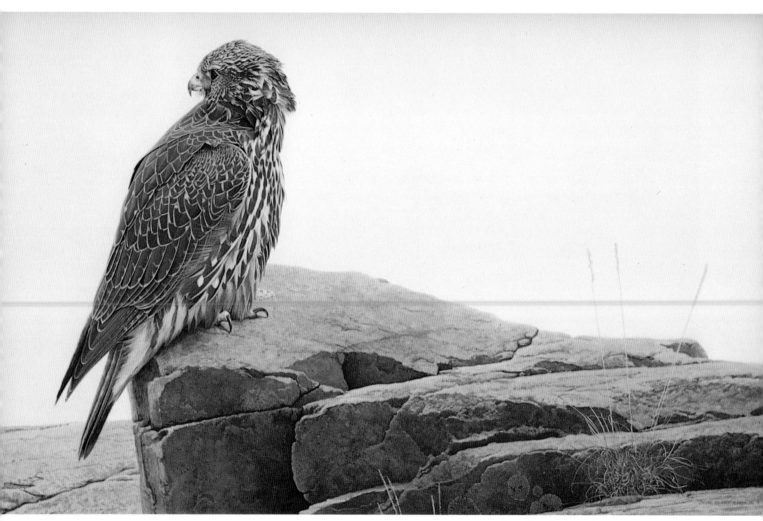

GYRFALCON
John P. Baumlin, Acrylic, 20" × 32"

Creating Interest
The gyrfalcon's unusual gesture draws immediate attention and having the bird looking out of the picture creates an interest in what lies beyond the frame. The arrangement of feathers as the falcon turns, as well as its feather patterns, are details that continue to hold interest.

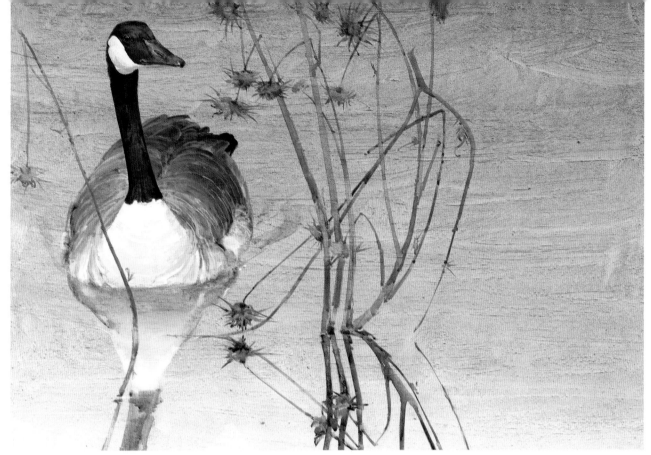

SWIMMING CANADA GANDER
Thomas Quinn, Gouache and acrylic, 29" × 38"

Gander's Glance
The gander's glance draws attention to the grasses and the mysterious space beyond.

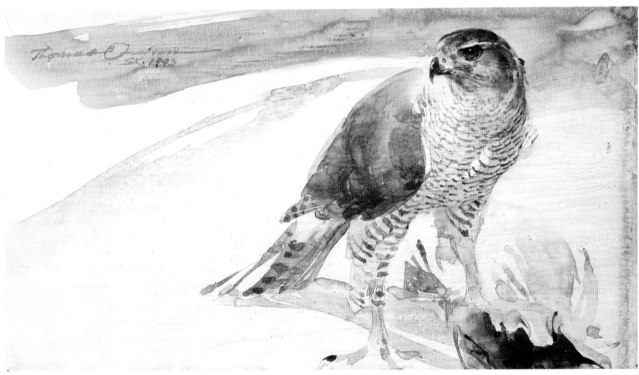

ANOTHER MEASURE OF BLUE
(Goshawk and steller's jay)
Thomas Quinn, Gouache and pencil on paper,
7¼" × 13¼"

Leading the Eye
Notice how effectively attention leads from the eye through the surrounding area.

Composing Groups of Birds

Individual placement within a group requires some observation. Pay attention to spacing. See how the birds react to each other. When sketching a group of birds on the water or in flight, sketch the flight pattern or spacing of the flock, just indicating the individuals with dots for quickness. The finished dots indicate a natural spacing that can be used for that particular species. You can accomplish the same thing by photographing the entire flock rather than just the individuals.

In some group situations, such as when birds are alarmed, a flock may all be looking in the same di-rection, but in most situations they are poised in different positions. Keep this in mind for more natural compositions. Also try to avoid spacing birds too evenly through-out the composition. An even dis-tribution is often boring, and can look unnatural.

Don't be afraid to overlap some birds within the group, because this will add variety and help give the illusion of depth. Some birds can have their backs to you, some can even be looking the other way, as long as you catch the eye of at least a few in the group. This is one situa-tion where quick gesture sketches can be very useful for planning a variety of bird positions.

The most important thing when planning a painting of a group of birds is to observe the natural group situation you want to depict. Dur-ing various times of the day, a flock might look and act differently. For example, most individuals within a flock of shorebirds will probably be very actively feeding early in the morning, late in the day, or at low tide. During less active times of the day, the activities might be more varied; some birds might be resting, preening their feathers or bathing, while others might still be feeding.

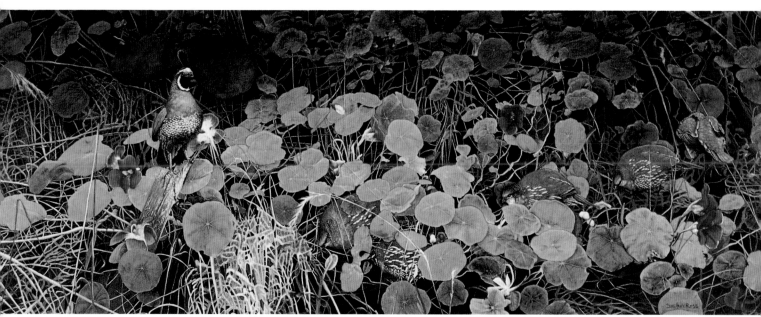

GARDEN SENTRY
Sueellen Ross, India ink, Watercolor and Prismacolor pencil on Arches paper, 15" × 40"

Employ Different Gestures
Painting a group usually involves em-ploying several different gestures. In this painting, Sueellen Ross does just that with a few birds blocked by vegeta-tion and one pointing away from the viewer, while an alert sentry watches for danger.

Group Composition

YELLOW-TUFTED WOODPECKERS *Bart Rulon* *Watercolor*

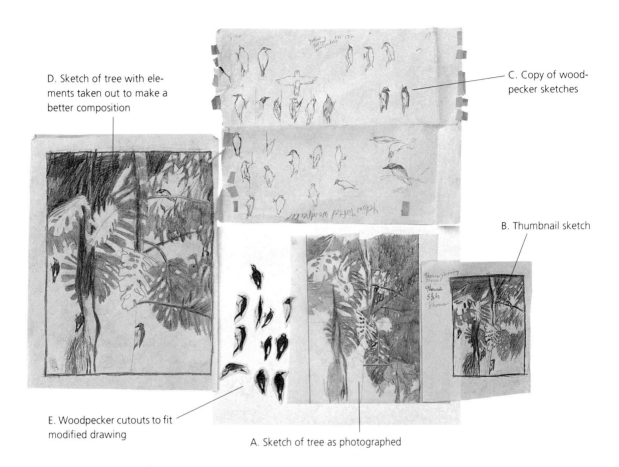

D. Sketch of tree with elements taken out to make a better composition

C. Copy of woodpecker sketches

B. Thumbnail sketch

E. Woodpecker cutouts to fit modified drawing

A. Sketch of tree as photographed

STEP 1

Number and Placement

I had plans to paint yellow-tufted woodpeckers in a treeside scene. The main questions were placement and number of birds. Sketches served as references, particularly for gestures.

Some drawings were done of the treeside (A, B). Then every sketch of the birds that looked like a possible candidate for this painting (C) was copied onto a separate sheet, in sizes to coincide with one of the drawings of the scene (D). Each different gesture was cut out (E), so that they could be moved around in different combinations. Some were turned over, and traced on the back with a contour outline, so the reverse image could also be used.

STEP 2

Fine-Tuning Positions

Larger cutouts were made of the woodpecker gestures and placed in different combinations on watercolor paper drawn with outlines of the major elements in the scene. The exact position of each woodpecker was fine-tuned using these cutouts.

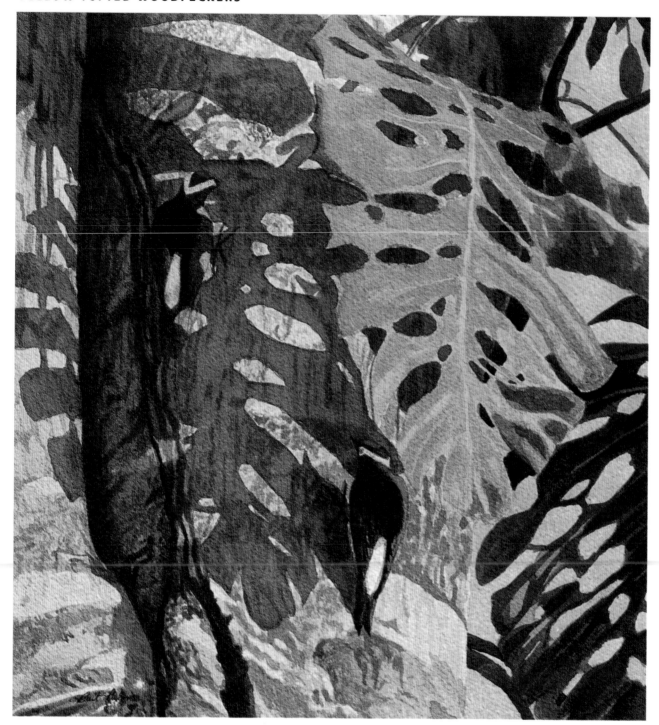

YELLOW-TUFTED WOODPECKER STUDY
Bart Rulon, Watercolor, 14" × 13½", Collection of Leigh Yawkey Woodson Art Museum

STEP 3

Color Study

This color study was used to test a composition of birds in the scene, drawing more attention to the light and shadow on two woodpeckers under a leaf. Had it been used, the birds would not have been noticed as well from a distance.

right

STEP 4

Directing Attention

I decided on one bird in profile against open sky to draw the viewer's attention quickly. From there the eye moves to the woodpecker on the bottom left, traveling up the treeside to find the last bird in the upper right corner.

YELLOW-TUFTED
WOODPECKERS IN ECUADOR
Bart Rulon, Watercolor, 30" × 22"

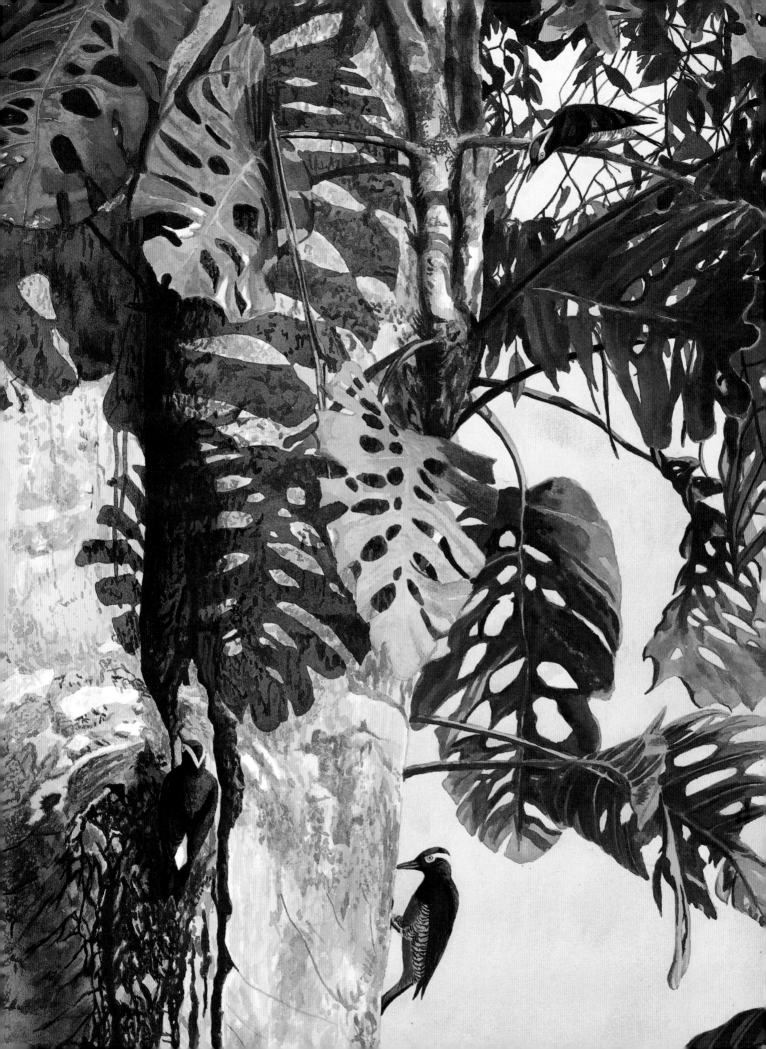

Keep Lighting Consistent

Make sure that the lighting on the bird fits the lighting situation of the scene it has been placed in. In addition make it a priority to understand what the correct lighting and values should be in your paintings before you start. Think of painting your subjects as shapes without details to work out the lighting and values. No matter how technically detailed you can paint a subject, it will not look realistic if the lighting does not correspond with the scene.

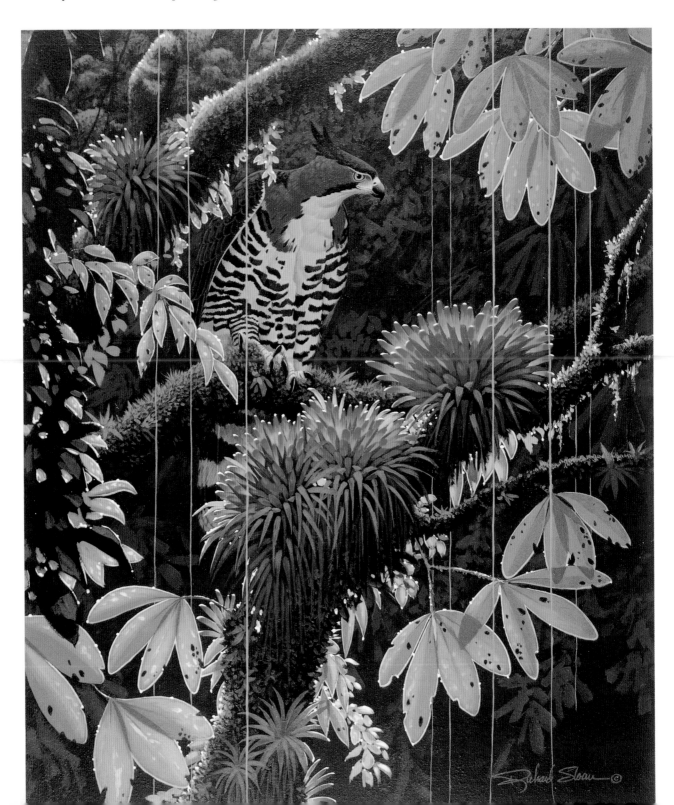

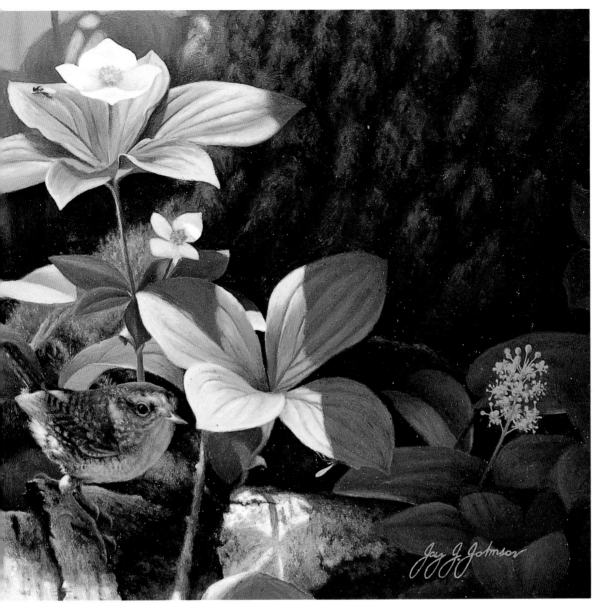

FOREST FLOOR
(Wren)
Jay J. Johnson, Oil, 8¼" × 9"

Light and Value

The lighting and values on the wren, partially in shadows and partially in sunlight, are very consistent with the strong sense of light and value in this painting.

left

HUNTER IN THE SHADOWS
(Orante hawk eagle)
Richard Sloan, Acrylic, 20" × 16"

Consistently Dark Values

The subject is in the shadow while vegetation in the foreground is brightly lit. Sloan painted the ornate hawk eagle in dark values consistent with the low amount of light that is reaching the bird.

Problem Solving: Lighting

Matching the light and shadows on a bird with those of a scene can be difficult when you combine a subject and scenery from different situations. You will need to adjust for differences in color, values and intensity of shadows.

Cloudy Day

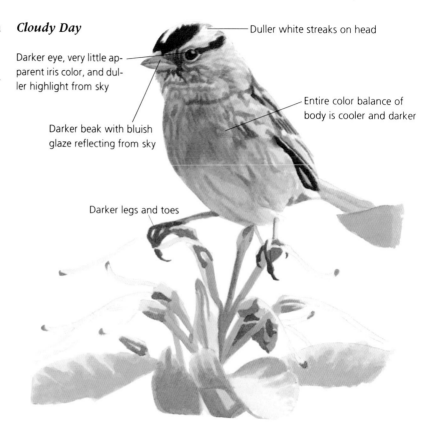

Duller white streaks on head

Darker eye, very little apparent iris color, and duller highlight from sky

Darker beak with bluish glaze reflecting from sky

Entire color balance of body is cooler and darker

Darker legs and toes

Sunny Day

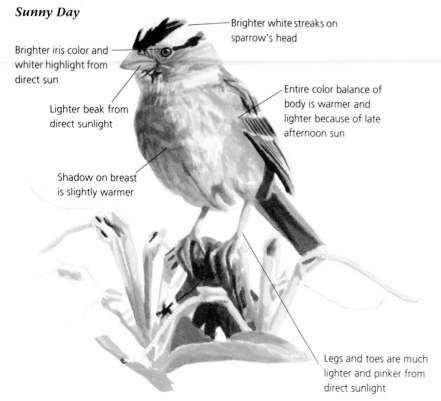

Brighter white streaks on sparrow's head

Brighter iris color and whiter highlight from direct sun

Lighter beak from direct sunlight

Shadow on breast is slightly warmer

Entire color balance of body is warmer and lighter because of late afternoon sun

Legs and toes are much lighter and pinker from direct sunlight

Different Lighting Situations
Two different lighting situations were used for these white-crowned sparrows. Notice how almost all aspects of the birds are different from each other.

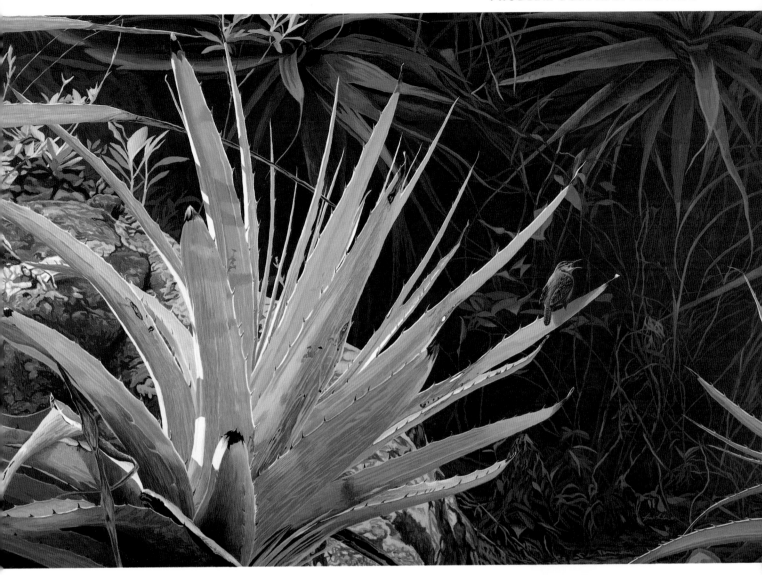

SONG ABOVE SAN PEDRO
Bart Rulon, Acrylic, 20" × 30"

Clay Models for Determining Correct Lighting

Clay models are great for determining how shadows would naturally fall on your subject in a certain lighting situation.

1. Mold a sculpture of your subject as you want it to appear in your painting. Support it so that both of your hands are free for drawing.

2. Take the model outside in a lighting situation similar to the one in your painting, as I did for this piece.

3. Turn the model to correspond with the angle of light in the painting.

4. Make a black-and-white tone drawing of how the light and shadows form on the model. This drawing will be a more reliable reference to work from than trying to make up the lighting situation from your imagination, because it will have come from actual observation. For this piece, to help determine how a shadow cast from the wren would form on the agave plant, I rolled up a piece of paper in the shape of a leaf, positioning it under the wren to duplicate that shadow.

Don't Outline

A common mistake is to unnaturally outline a bird's body to distinguish it from a background of the same color. In such situations, part of a bird's body may naturally blend in with the value or color of its immediate background, making it difficult to see an obvious division between the two. Adding an outline around the body when you can't actually see an outline will make a bird look flat and "stuck on" rather than fitting into the painting naturally. Trust your eyes in these situations.

Don't outline any part of a subject's body to differentiate it from a background, unless that is actually the way you see it. Notice the upper mandible of the Violet Sabre-wing's bill. Though the culmen (upper edge of the bill) is barely visible, Chris Bacon did not outline it to define it.

CLOUD-FOREST JEWEL *(Violet sabre-wing) Chris Bacon, Watercolor on rag board, 15" × 10"*

Use Consistent Colors

The lighting situation will usually dictate how much similarity between colors there is naturally in a scene. For example, foggy days or other low-light situations will usually cause the colors in a scene to look very similar. That same scene in full sunlight might have a much more varied number of colors.

Using the same colors throughout a painting can be especially useful when you are using several unrelated references from different lighting situations to complete one work. For instance, you might be using one picture of a bird in the sun and one of a bird in shadow (from two different situations) as reference for a scene where both birds will be in shadow. You will want to modify the colors and values of the bird in the sun to match the bird in shadow. Using the same colors (or very similar colors) as the bird in shadow will help make them both fit naturally in the scene.

EL MUNDO PERDIDO
(Red-lored parrot)
Terry Isaac, Acrylic, 20″ × 9″
Artwork courtesy of Terry Isaac, copyright 1994,
and Mill Pond Press, Inc., Venice, Florida, 34292.

Consistent colors throughout this painting help make everything look natural (especially important in a misty situation).

Achieving Color Harmony

John Baumlin usually restricts his palette to three or four colors. Since the color of the goshawk was most critical in this piece, he developed it first as a benchmark for the rest of the painting. He completed the first thin coat with a mixture of Burnt Umber and Ultramarine Blue, white for various values, and a little Raw Sienna for slightly warmer areas.

John then painted the entire goshawk almost to completion, making color adjustments as needed. He says, "By adding a little Indian Red to the Ultramarine Blue, it would not turn greenish when mixed with the Burnt Umber for the gray I needed." He then worked on the trees, using the same three pigments (Indian Red, Ultramarine Blue and Burnt Umber) in different proportions, using the hawk for color comparison.

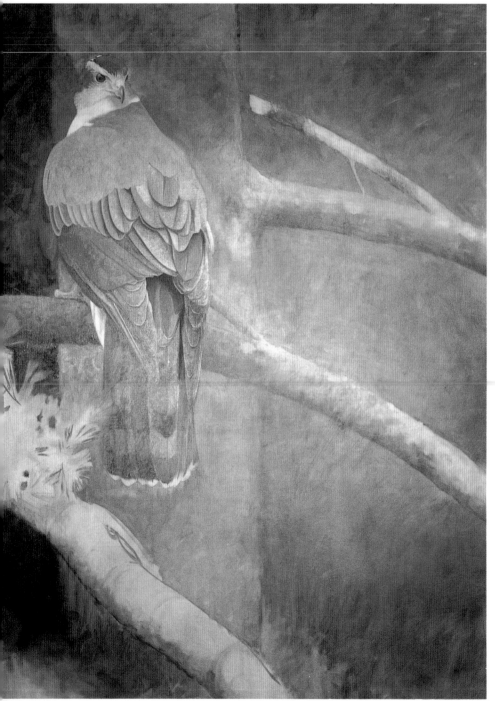

Initial Color Block-In

right
GOSHAWK
John P. Baumlin, Oil, 32" × 24"

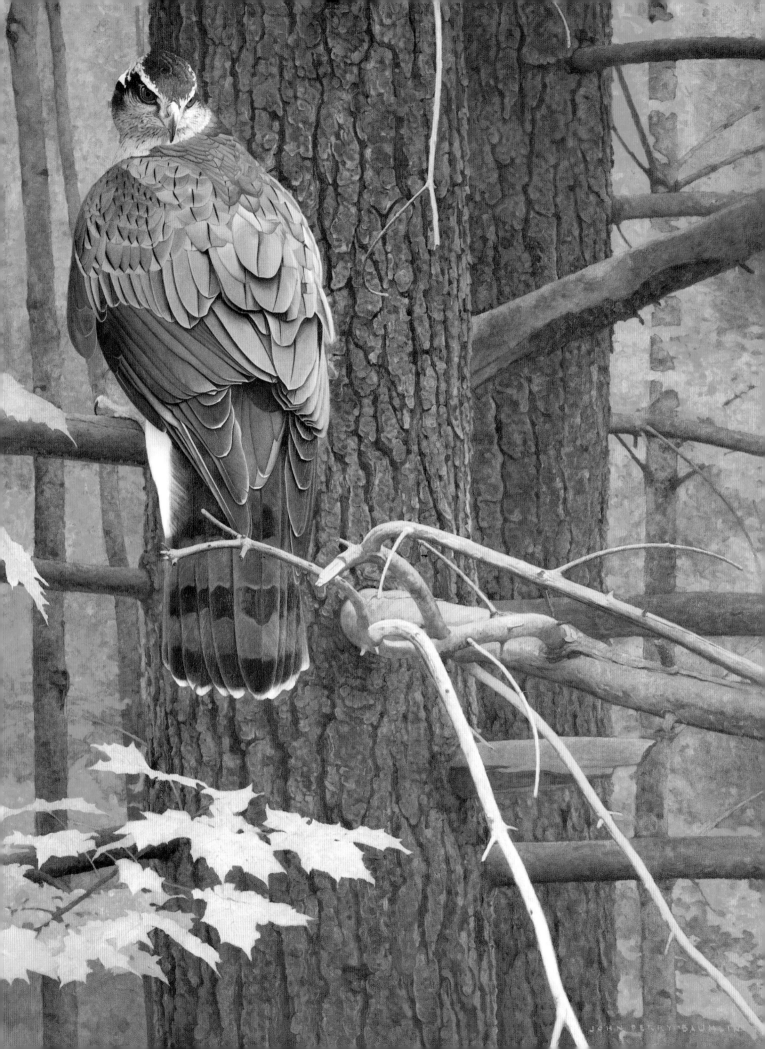

Painting Feathers

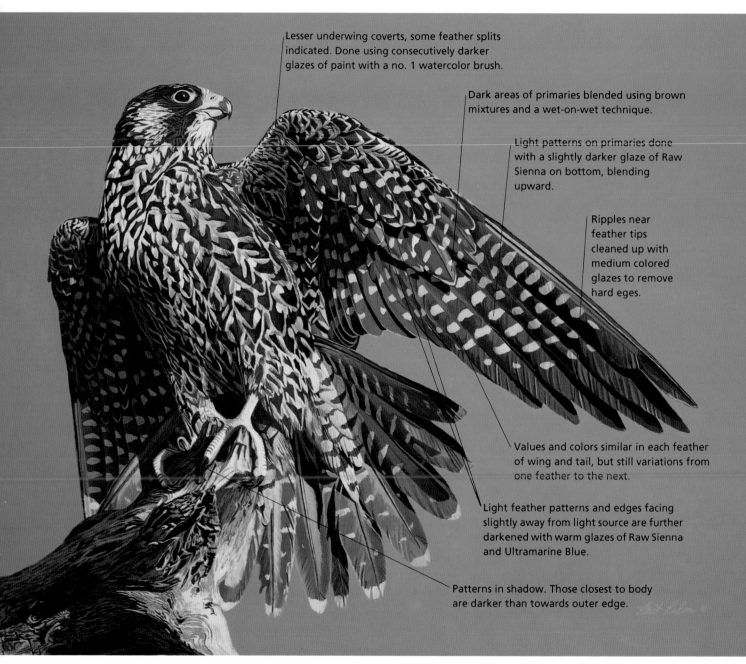

Lesser underwing coverts, some feather splits indicated. Done using consecutively darker glazes of paint with a no. 1 watercolor brush.

Dark areas of primaries blended using brown mixtures and a wet-on-wet technique.

Light patterns on primaries done with a slightly darker glaze of Raw Sienna on bottom, blending upward.

Ripples near feather tips cleaned up with medium colored glazes to remove hard eges.

Values and colors similar in each feather of wing and tail, but still variations from one feather to the next.

Light feather patterns and edges facing slightly away from light source are further darkened with warm glazes of Raw Sienna and Ultramarine Blue.

Patterns in shadow. Those closest to body are darker than towards outer edge.

IMMATURE PEREGRINE FALCON
Bart Rulon, Acrylic, 15½" × 20"

When dealing with feather patterns, pay strict attention to large markings. Employ a combination of reality and improvisation for the areas in between. Also remember that patterns appear more compressed as they follow the rounded forms of a bird towards its contour edges. Such variations are important in portraying three dimensions.

Tips From the Pros

"When overwhelmed by the complexity of a pattern, isolate areas and paint one small area at a time."

—*Terry Isaac*

Feather Spacing

Some feathers, such as the primaries, primary coverts, secondaries, greater wing coverts, and tail feathers appear relatively evenly spaced, but the rest of the contour feathers are not nearly as uniform-looking, even if only slightly varied. Be careful to observe each species individually.

Even wing and tail feathers, most evenly spaced when spread, aren't always so uniform, depending upon how they are being held. In general, as you move inward on the wing, from the primaries and secondaries toward the smaller feathers, you are going to see less and less uniformity. Depicting slight variations in feather placement is important to make a bird look convincing.

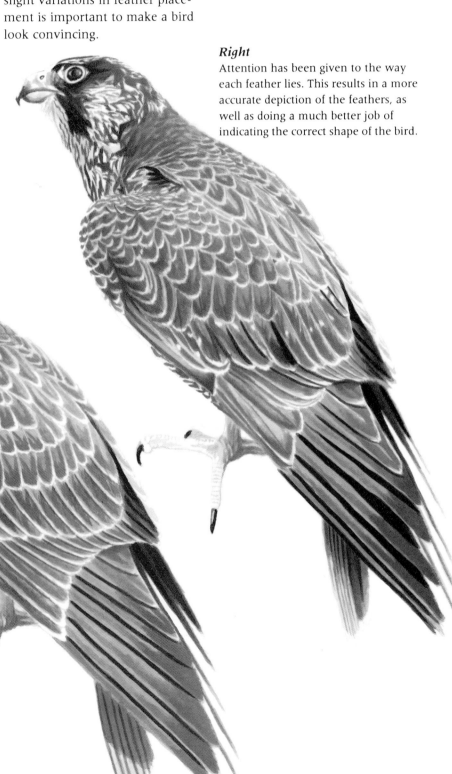

Right
Attention has been given to the way each feather lies. This results in a more accurate depiction of the feathers, as well as doing a much better job of indicating the correct shape of the bird.

Wrong
Feathers are too evenly spaced, looking like fish scales rather than feathers.

Eyes

There is no foolproof rule for painting eyes. The quality and direction of the light source, surrounding colors, and actual color of the eyes all affect how the eye looks.

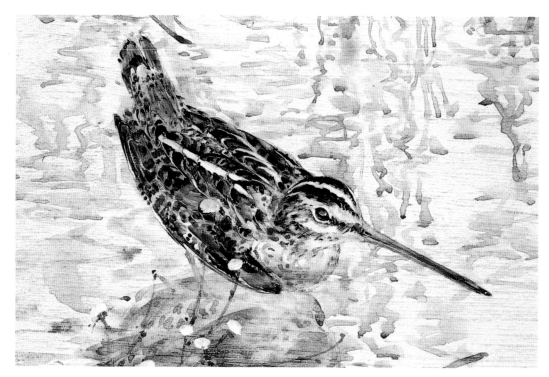

DETAIL OF SNIPE
Thomas Quinn,
Gouache and acrylic,
25" × 38"

Consider the Surroundings
A detailed view of Thomas Quinn's snipe shows how part of the eye reflects the sky and the other part reflects the surroundings underfoot.

 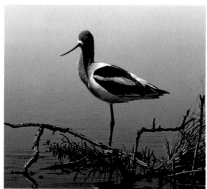

BACKWATER BALLET
(Avocet), Terry Isaac, Acrylic, 8¼" × 13½"
Artwork courtesy of Terry Isaac, copyright 1987.

Highlights
An eye facing the sun will have a bright highlight on a sunny day. Compare the eyes pictured here. They are painted representing the exact same lighting situation, with the only difference being that the heads are turned differently. Notice how the bright highlight in the eye is located in a different spot in each case because the bird's head is turned in relationship to the sun.

No Highlight Needed
An eye shaded from the sun will not have a bright highlight. Notice that Terry Isaac did not paint a white highlight in the eye of the avocet above because it is facing away from the light source.

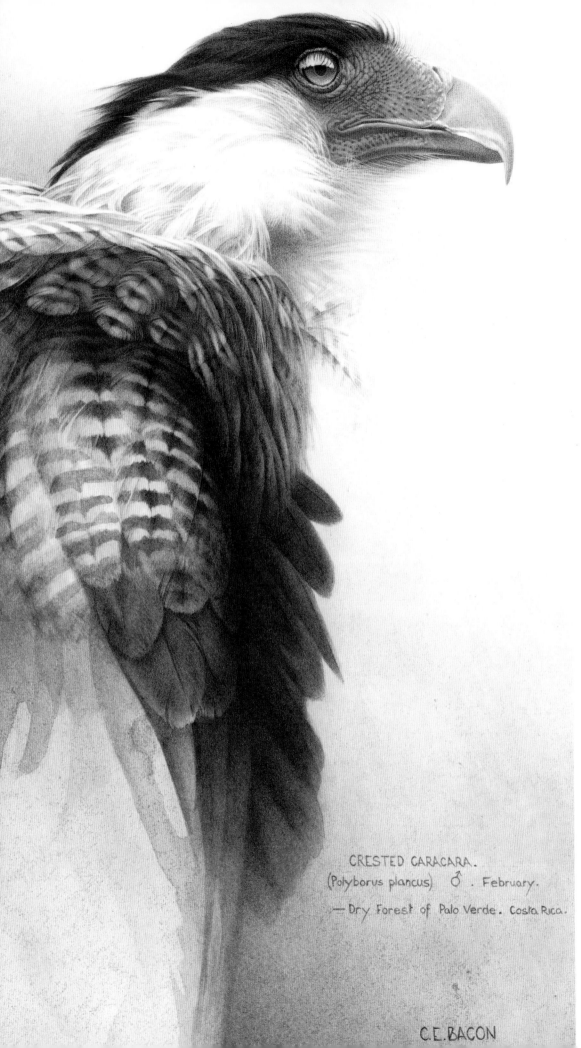

CRESTED CARACARA.
(Polyborus plancus) ♂ . February.
— Dry Forest of Palo Verde . Costa Rica.

C.E.BACON

CRESTED
CARACARA
STUDY
*Chris Bacon,
Watercolor on rag
board, 10" × 6¼"*

Eye Reflection
Notice how broad
the reflection is,
and how the eye
reflects its sur-
roundings. The
upper part reflects
the sky on a more
overcast day, with
the light source
diffused by
clouds. A small,
bright, white
highlight does not
happen in all situ-
ations, and should
never be added
unless you can ac-
tually see it.

Painting Nests

"Birds' nests vary not only from species to species, but from one individual to the next in their particulars, depending on the situation and materials used," says artist John P. Baumlin. "Some nests are singularly attractive in their own right, due to the materials used and the meticulous care in their construction. Others, for instance those of some hawks, are not much more than a heap of sticks. I'm still concerned that the nest, as painted, will have some visual interest as well as plausibility.

COOPER'S HAWK CHICKS
John P. Baumlin, Watercolor, 14" × 23½"

At Close Range

This cooper's hawk nest was about thirty-five feet off the ground. John P. Baumlin was able to climb up the tree to sketch and photograph it at close range. In regard to this scene, Baumlin says, "Part of the secret of its charm was in the contrast between the somewhat untidy platform of a nest and the immaculate and quiescent young birds."

''Nests present an interesting challenge. The two most important considerations, as always, are the appearance of realism and beauty of form, standards difficult to achieve unless one is working from the actual subject.''

Baumlin approaches painting a bird's nest a little differently with each medium. With watercolor, he starts out with a carefully detailed drawing of all the sticks included in the nest. Next he paints the dark areas in between the sticks, and last he works on the sticks themselves. In oils, Baumlin starts with a rougher pencil drawing, indicating the major directions of the branches. Next he blocks in a middle value for the entire nest, then blocks in the darker values and, lastly, the lighter values. Some of this is done wet-into-wet and some is done wet-over-dry. With these basic values indicated, Baumlin works back and forth between darks and lights until all the details are in.

When painting nests, John uses references he has found in the wild. He tries to stick to them literally, rather than making up any areas within the nest, though he will leave out any sticks or other contents of the nest that look too awkward. John likes to choose nests that look presentable as found in nature, so that editing can be kept to a minimum.

HARRIS HAWK AND SAGUARO
John P. Baumlin, Oil, 18" × 24"

Acrylic and Oils
The nest in this painting was blocked in with acrylic first, then oils were used for the majority of the detail work.

117

Painting Birds With Mammals

Lindsay Scott says, "I will often combine birds and large mammals in my work. Birds can be a very useful compositional tool because they can fly. They do not have to be standing on the ground as mammals usually do so they can be used to define a space, or put some interest in an otherwise blank area. For people who paint mammals, they can be quite handy to liven up a 'dead' area of a painting."

CAPE BUFFALO AND CATTLE EGRETS
Lindsay B. Scott, Oil, 8" × 30"

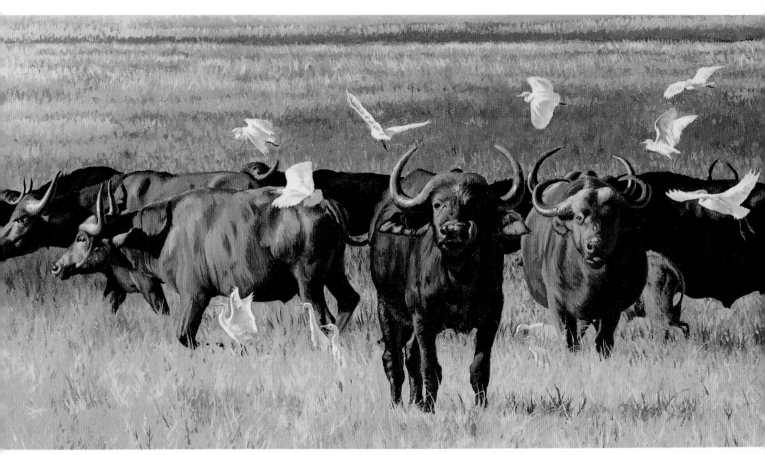

Light and a Sense of Space

Both of these elements are accentuated by the use of birds along with the mammals. Being able to put white birds against the dark-shadowed grass really emphasizes the light. Being able to do the reverse with birds in the shadows against the light grass in the background adds to the complexity of the piece, which is based on a very simple idea.

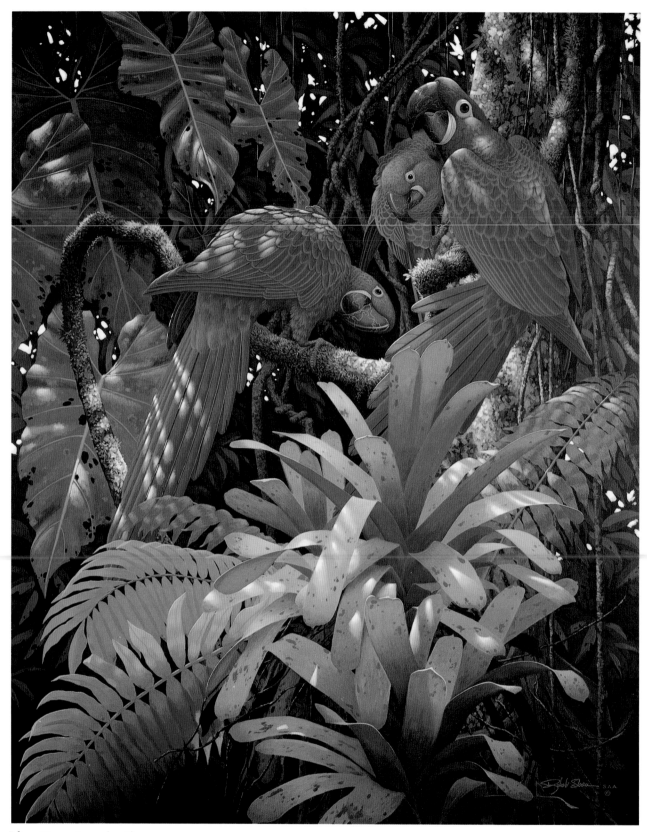

Ideas From Imagination

The idea for this painting started in the artist's head. It was further developed using references. Sloan found a gray/yellow bromeliad that would complement the birds' colors well, and visited the Phoenix Zoo to look for unique macaw poses.

TRIPLE THREAT
(Hyacinth macaws)
Richard Sloan, Acrylic 40" × 32"

Sources for Ideas

Making good choices about both the *idea* and *composition* for each painting is essential. You can improve your work considerably by developing good picture-planning skills.

There are two main sources for ideas: (1) Witnessing birds and representing what you saw and (2) creating an imaginary scene that could happen. The first category is easier and often more successful because the idea will be concrete in your mind.

Imagination allows unlimited possibilities, but creating a painting without firsthand experience demands planning. The image in your head must be clear.

Sometimes the idea for a painting may be strong, but the references to support it are weak. In that case, additional trips to the source of inspiration are essential. Richard Sloan's ideas for paintings are usually based on something he has experienced firsthand, but he will sometimes develop a scenario in his imagination. While developing that idea in a sketch, he goes to his reference library of slides to see if he has enough visual information to produce the painting. If he doesn't find enough, he takes a "want list" of photos he needs as reference on his next field trip.

ELEMENTS OF IDEAS

In this chapter we'll explore some elements to look for as critical parts of good painting ideas.

Limit paintings to one theme. Too many ideas in one painting confuses the viewer. For example, a loon on a calm lake, at sunset, with mountains in the background and an eagle flying overhead may simply be too much. You can have several different subjects, but they should all support one idea.

Having a unique idea that draws attention and holds interest is important. On the following pages are some keys for making your work stand out.

Tips From the Pros

Start thinking about *what it is that you want to say* instead of just striving for technical success. Art goes much further than mere representation.
—*Bart Rulon*

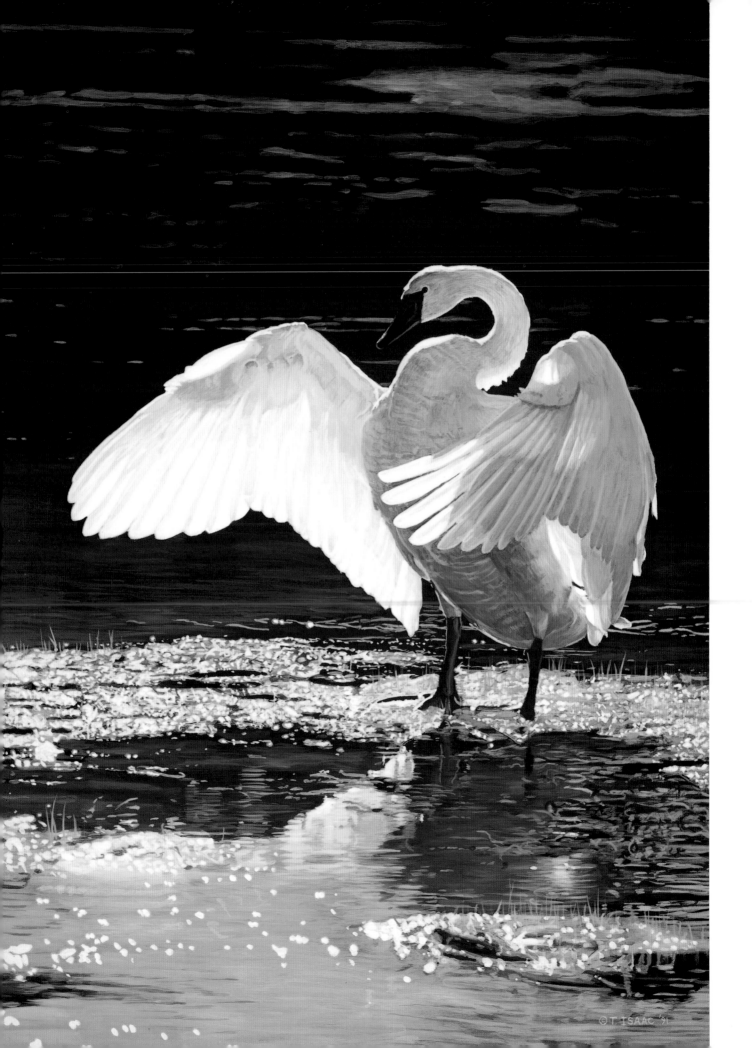

© T ISAAC '91

Unique Lighting & Shadows

left

INTO THE LIGHT
(Trumpeter swan)
Terry Isaac, Acrylic, 15½" × 10¼"
Artwork courtesy of Terry Isaac, copyright 1991,
and Mill Pond Press, Inc., Venice, Florida 34292.

Lighting can make a painting work regardless of the subject. Many interesting effects happen early or late in the day, when long shadows, coupled with areas of sunlight, make for interesting scenes, and often help define the form of a landscape or bird.

Forests are great places to look for unique situations during midday hours, when streaks of light streaming through the forest canopy add abstract qualities.

In general, look for side and back lighting on birds and their habitats. Notice how the setting or rising sun warms and softens the colors on a bird and its surroundings. In the painting at left, strong backlighting invites the viewer in for a closer look.

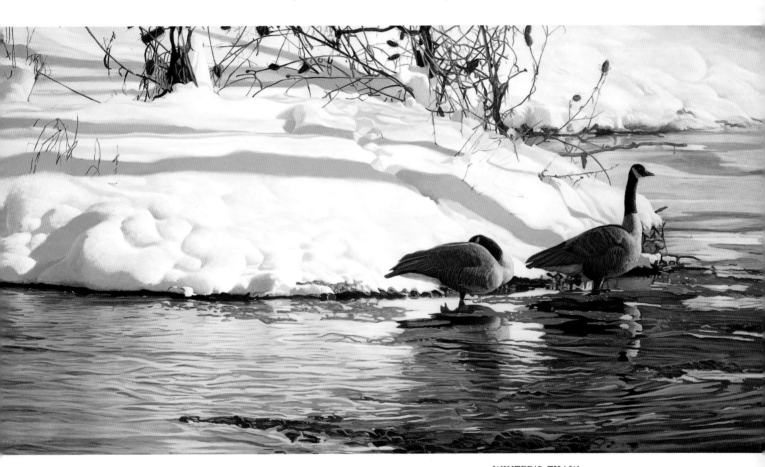

SHADOWS

Shadows are powerful elements of design that can lead your viewers through a painting. They can add abstract qualitites to your work, give the illusion of depth and atmosphere, and define form. Here, shadows on the snow and geese clearly indicate their forms. Some are obviously from objects outside the picture frame. They give clues to what the larger scene must look like. The horizontal ones serve another important role by leading the viewer's eye to the main subjects, creating a very cohesive design.

WINTER'S THAW
(Canada geese)
Terry Isaac, Acrylic, 18½" × 36"
Artwork courtesy of Terry Isaac, copyright 1990,
and Mill Pond Press, Inc., Venice Florida 34292.

© C.E. BACON '88

Distinctive Poses & Camouflage

Unique poses are essential to good ideas. Look for different gestures that are natural, yet unique and intriguing: the way a bird turns its head or stretches its wings out; the way it looks with its head pointing straight at you; any number of different gestures. Profiles are painted often. They may be fine, but a piece could be improved by choosing a more interesting and unique position. Try to show the bird in a fresh and revealing way.

Lots of sketching and photography fieldwork is essential here, along with patient observation. Take full advantage of the opportunity to observe all the gestural possibilities of a bird.

A strong point of Chris Bacon's work is his ability to utilize unique and interesting gestures. Here, the heron's neck as it turns, the resulting separation of feathers on its left, and its intense stare all add power to the piece.

TIMBERDOODLE
Paco Young, Oil, 16" × 40"

CAMOUFLAGE

Many birds have cryptic plumage as a defense against predation. Painting these species offers great opportunities to deal with pattern, but presents challenges when planning a composition. If you make the bird or birds too difficult to recognize in the painting, viewers will lose interest, even though in real life it is often impossible to spot these well-camouflaged species until they burst into flight. Leading the viewer's eye gradually to the subject is a very important element in painting a camouflage scene. Avoiding confusion by giving the eye places to rest within the composition should be worked out in the early stages.

The cryptic plumage of a woodcock is used very well as the major theme in this painting. The bird is not spotted immediately, yet its placement is such that you are not searching forever to find it, either, which could cause viewers to lose interest.

Unique Behaviors

TIME FOR LUNCH
(Great egret)
Dino Paravano, Pastel, 21" × 29"

Birds are fascinating creatures. Such spectacles as masses of shorebirds feeding, mating displays, and individual mannerisms like tail bobbing are just a few of the behaviors that make birds so intriguing.

These behaviors can be important elements in painting a bird convincingly and uniquely. The behavior does not have to be flamboyant to work. It could be as simple as how a robin tilts her head when searching for worms, or how an adult bird feeds his or her young.

We most often think of egrets preying on fish, but here the artist portrays one after capturing a lizard. That water is not depicted is also unique, because so many egret paintings include a water backdrop. Finally, the wind blowing this bird's feathers out of place brings in another important element, helping us to "feel" the breeze.

126

Tension

COMMON YELLOWTHROAT
Chris Bacon, Watercolor on rag board, 6½″ × 9¾″

Tension involves the viewer by imagining the continuance of action. It can also be achieved by poising a bird such that an action is about to happen. The tension created just before a warbler moves from one branch to another, before a hawk takes flight, or before a heron thrusts forward to capture a fish are just a few examples of situations where you can use this built-up energy in your work.

Tension is created by this yellowthroat poised on a branch and looking into the distance. A possible connection is drawn between its gaze and its next move. Branch diagonals also lead in the general direction of the yellowthroat's focus, adding to the feeling of potential motion.

Action & Unusual Viewpoints

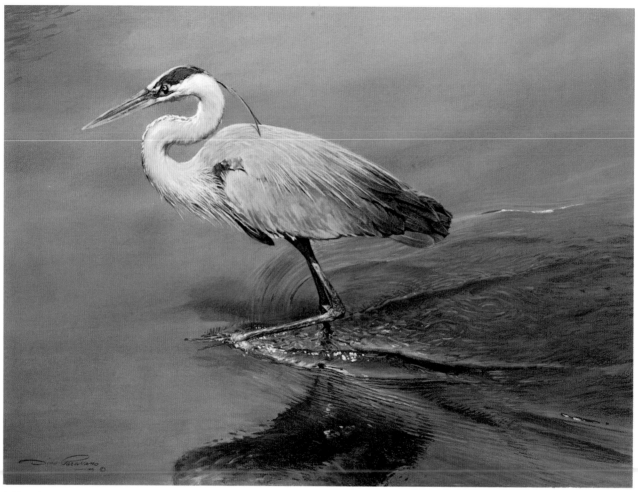

OUT OF THE SHADOW
(Great blue heron), Dino Paravano, Pastel on Canson paper, 21" × 29"

Action draws attention and can be a very dynamic and exciting reason for doing a painting. Depicting a bird in flight or the suspense of a life-and-death chase can really get a viewer involved in a painting. See *Hawk and Grouse* on page 13. Viewers become involved in the piece by imagining the sequence of events leading up to and following a bird's actions. The uniqueness of *Out of the Shadow* is in part due to the illusion of motion captured as the heron walks through the calm water, creating ripples on its surface.

LOOK AT SCENES FROM DIFFERENT VIEWPOINTS

Think about what things are like glancing up into a tree or straight down from a cliff to a body of water below. Consider painting a bird in a more unusual part of its habitat. For instance, great blue herons are most often near a body of water, but they will also hunt for prey such as insects, mice and voles on land. Woodpeckers are most often on tree trunks where they spend a lot of time looking for insects, but they will also forage for fruit on small branches or on the ground.

These other scenes rarely get painted. You can probably find aspects of a bird's habitat which you've never seen depicted in a painting before. Why not be the first one to do it?

At right is an unusual vantage point, from above the subject, looking down over the Peruvian Amazon. The artist gives us an idea of what it must be like to be out on that limb overlooking the distant river and forest below, helping us relate to a place few have seen. Perhaps more than any other painting, this one sums up the overwhelming beauty of the rain forests.

ABOVE THE URUBAMBA *(Andean cock-of-the-rock), Richard Sloan, Acrylic, 28½″ × 18″*

Raymond Harris-Ching on Painting

GOOSE ATTACK!, *Ray Harris-Ching, Oil on panel, 15″×20″, Collection of the Tryon Gallery, London*

"I doubt there really could be just one right way . . . to approach the construction of a particular painting. Why you do it is an altogether different, but no less important matter. Why you paint at all is about your need to do it, and unless this urge is undeniable—really won't be denied—just has to be got down onto paper—unless this is so, then no matter what the technique employed, it will all be for nothing. . . .

"If ever I am able to wrench anything of interest out of a bird subject, it is because just then—at that time—as I see it—my need to draw it has such an urgency, such a hope

to describe what it is to me, what I make of it and why I've bothered or had the requirement to even begin, it is in this tangle that the possibility of unraveling something wonderful lies.

"It can't possibly be enough just to describe in paint the beauty of a bird's plumage, for long before you begin your painting, we have already known that a bird is a beautiful thing. It simply can't be enough only to describe, no matter how faithfully, the precise color and patterns that structure the creature's beauty: these patterns are already well noted in any of a hundred field-

guides. It's so easy to be trapped into assessing that these things, beautiful in themselves, may automatically be enough to carry the drawing or painting along, whereas, really, they are not. If the painted bird is to have any impact at all as a piece of art, then a way must be found to paint not just what it looks like, but what it means."

This painting exhibits the power of capturing character. Ray Harris-Ching says, "It is drawn direct from nature. . . . Just a portrait of a hissing goose—but a painting that does, nonetheless, contain in it some of the actual life force of a real bird."

130

Contributing Artists

Chris Bacon

was born in Watford, England in 1960. He has traveled extensively and lived in remote areas of the world such as Ascension, Fiji and Bermuda. This exposure to an exotic 'feast for the senses' fostered an early appreciation of the natural world. His inherent drawing ability was always encouraged, and it wasn't long before these two interests came together.

The artist moved to Canada as a teenager, where he still resides. Working primarily in watercolor, he continued to paint the subjects he loved, scenes that almost always included animals or birds. Not long after, and with no formal art training, Chris held his first solo exhibition. Since then, he has been included in ten exhibitions with the Leigh Yawkey Woodson Art Museum, and is a member of the prestigious Society of Animal Artists where he has had the honor of receiving their coveted Award of Excellence three years in a row (1992, 1993 and 1994).

John P. Baumlin

was born in upstate New York in 1956 and began drawing animals and birds at about age five. He says, ''This early preoccupation with animal form has remained a constant. . . . After a brief flirtation with the idea of pursuing a career in architecture, I dropped out of college and began painting full-time. The next several years were spent honing my skills. . . . My influences during this period were Bob Kuhn, George McLean and a few others in whose work I saw glimmerings of recognition.'' John's work has been shown at the Leigh Yawkey Woodson Art Museum in Wausau, Wisconsin, The National Art Exhibition of Alaska Wildlife in Anchorage, and Arts for the Parks exhibitions in Jackson, Wyoming, as well as other exhibits in Japan and the Middle East.

Ray Harris-Ching's

childhood sketches from nature at his family's isolated New Zealand farm, which sowed the seeds for a body of work spanning four decades. Born in Wellington, New Zealand in 1939, his obsession with depicting the wildlife around him emerged early, and has been dominant in his artistic output ever since.

Demand for his intriguing and beautiful paintings exceeds their supply, and many books have been published on his art. In the first of these, *The Bird Paintings* (1978), his development through early, brilliant watercolors to later works in oils is well documented. A second, *The Art of Raymond Ching* (1981), shows him not only as a painter of birds and mammals, but reveals him to be an artist equally involved in painting the people around him—his family, friends and neighbors, as well as commissioned portraits. Best known for his animal paintings, this large body of work is further explored in *Studies & Sketches of a Bird Painter* (1981), *New Zealand Birds* (1987), *Wild Portraits* (1988), *Journey of an Artist* (1990), and most recently *Voice from the Wilderness* (1994), a collection of startlingly original and often unsettling paintings of considerable power, as well as drawings of unmatched elegance.

Terry Isaac

lives in the Willamette Valley of Oregon. He paints North American (and recently Central American) wildlife and landscapes. Although Isaac received a formal art education, graduating with honors, he believes his best training has come from being outdoors and studying the work of favorite wildlife artists like Robert Bateman.

Isaac, painting in acrylics, strives to capture characteristics of wildlife and its surrounding light. He is inspired by large panoramas as well as up-close views, and by subjects from whales to hummingbirds. Isaac has been selected to participate in several important art exhibitions, including the Leigh Yawkey Woodson Art Museum's prestigious annual "birds in Art" since 1987, and "Wildlife: The Artist's View" in 1990 and 1993. He was also selected for "Wildlife Art in America," an exhibition at the James Ford Bell Museum of Natural History in Minneapolis in 1994. He was commissioned to painting the 1991 New York Duck Stamp, and to create fourteen waterfowl drawings for the *Audubon Bird Handbook*, published in 1987.

Isaac taught middle school art for eight years before turning to art full-time. His paintings have been published in limited editions by Mill Pond Press of Venice, Florida, since 1988.

Jay J. Johnson

graduated from Cornell University and then completed one of the longest wilderness journeys around America (ten thousand miles and sixteen months of walking, paddling and bicycling). After that he began communicating his love for nature through paintings that have since been exhibited at the U.S. Embassy in Moscow, the National Wildlife Art Museum, and the prestigious Leigh Yawkey Woodson Art Museum, among many others. Johnson brings his sensitivity for light and atmosphere to each painting along with his diverse hiking and paddling experiences, to create images in oil paints that range from close-ups of small birds to panoramic views inhabited by large mammals. Prints of his paintings are now published by the Greenwich Workshop, and originals are available through the Big Horn Galleries in Carmel, CA; Aspen, CO; Cody, WY; and Fairfield, CT.

Dino Paravano

was born in Italy, and moved to South Africa with his family in 1947. He attended the Johannesburg College of Art. Dino presently lives in Tucson, Arizona.

Dino is an international artist. Since 1965 he has held fourteen one-man exhibitions in South Africa, New York and London. He has participated in over 160 group exhibitions internationally, 65 of which were museum shows. Dino has participated in the "Birds in Art" exhibition for nine consecutive years and for three in "Wildlife: The Artist's View," both held by the Leigh Yawkey Woodson Art Museum.

Dino has work in museum, corporate and private collections throughout the world, and over thirty limited edition reproductions. He is a member of the Society of Animal Artists, and the Pastel Society of America. He is a recipient of the International Wildlife Show Best of Show and Merit Award (Cincinnati, Ohio, 1983) and Society of Animal Artists Award of Excellence, 1991.

Dino has illustrated two books by best-selling author Peter Hathaway Capstick, *The Last Horizons* and *Death in a Lonely Land*, 1989-1990, published by St. Martin's Press, New York. Dino also executed seven dioramas for the South African Nature's Conservation Centre in Johannesburg.

Dino has been featured in *Safari Club International Magazine*, *Hunters Quest Magazine*, *Wildlife in Art*, *Sporting Classics*, *American Artist*, *Panorama*, *Signature*, *Flying Springbok*, and *In the Clouds*.

Thomas Quinn

lives and paints on the northern coast of California. The philosophy of "less is more" is evident in Quinn's art. He has "always admired the magic of negative space, what is left unsaid." One finds in the elegance and simplicity of his art intriguing parallels with the Chinese masters of the Sung dynasty and eighteenth-century Japanese landscape painters.

Quinn graduated with distinction from the prestigious Art Center College of Design in Los Angeles. He has had exhibits at galleries and museums around the country, including a one-man show at the Frederic Remington Art Museum in 1988. Quinn is a regular exhibitor at the Leigh Yawkey Woodson Art Museum's "Birds in Art" show; his work is also among the Museum's permanent collection as well as the permanent collection of the National Wildlife Art Museum. He was also included in Susan Rayfield's book, *Wildlife Painting: Techniques of Modern Masters.* Quinn's paintings are collected by a strong patronage and are hung in numerous museums. He is the author of *The Working Retrievers*, a large, handsome volume, written in an exceptional narrative style, now considered a classic on the subject of field retrievers.

Sueellen Ross

is known for her work in original intaglio prints, and has turned more and more to mixed-media paintings. She says that etching taught her how to "design major pieces that are strong in texture and line, brilliant in color, and meticulous in detail."

Ross is known for both her strong design and her subtle humor. Her lively images are based on her own experiences; as a city person, she often approaches wildlife from the urban dweller's point of view.

Ross attended the School of Visual Arts in New York City, and received her bachelor's and master's degrees from the University of California at Berkeley. She has numerous awards and credits to her name, including the American Artist Collection (*American Artist Magazine*, 1990), and Region One winner for "Arts for the Parks" competition in 1991. Her work is often included in shows like "Birds in Art" at the Leigh Yawkey Woodson Art Museum and "Arts for the Parks."

Lindsay B. Scott

was born and raised in Zimbabwe. She studied at the Michaelis School of Fine Art, Cape Town, and received her Fine Art Degree with a minor in biological sciences from the University of Minnesota.

Lindsay's art has been exhibited in invitational, juried and one-woman shows all over the world. The Leigh Yawkey Woodson Art Museum's "Birds in Art" has included her work for nine years, and has purchased one of her originals for its permanent collection. Six pieces of Lindsay's work were sold in the 1994 Wildlife Art Auction at Christie's, London.

In 1992, Lindsay was selected for the "Uniting Artists Across Continents" cultural exchange to Botswana, Namibia and South Africa, along with Bob Kuhn, Guy Coheleach, Mort Solberg and Paul Bosman. She was awarded Best of Show and First Place at the Pacific Rim Wildlife Art Show in Tacoma, Washington, and an Award of Excellence at the Society of Animal Artists. The Leigh Yawkey Woodson Art Museum invited her to give a workshop in conjunction with the 1992 "Birds in Art." She has gone on to win many more awards, and her work has been featured in *Wildlife Art News, U.S. Art, Bird Watcher's Digest, Informart, Sporting Classics,* and *Bird Painting Techniques of the Modern Masters* by Susan Rayfield. Her work is published by Applejack Limited Editions.

Having spent a year living in the U.S. Virgin Islands, Lindsay and her husband, Brian McPhun, have returned to Ventura, California, still making frequent research trips back to Africa. Although she is best known for her pencil drawings, she also works in oils.

Photo by Alexander Lowry.

Dave Sellers

began his career early. In high school, inspired by both his interest in an active outdoor life and love for art, he began to combine these interests into a hobby. While attending Humbolt State University in the redwoods of northern California, he began to develop his hobby into a career. Eventually, he used his art to finance his education in art, biology and history.

Dave's art career has grown beyond his hopes. He attributes his early success to approaching his art with an in depth understanding of his subjects. With his most frequent subject, waterfowl, he not only studies wild birds in their native habitat, but also maintains a collection of live North American waterfowl. This commitment is reflected in his work, which has been chosen four times for the prestigious "Birds in Art" exhibit sponsored by the Leigh Yawkey Woodson Art Museum in Wisconsin. He was also named "Artist of the Year" by California Ducks Unlimited for 1990-91, and "Artist of the Year" for the California Waterfowl Association in 1991-1992.

Beyond his waterfowl paintings, Dave has developed a following as a California wildlife and landscape artist. His recent body of work involving mountain lions was inspired by his assistance in an extensive study of these wild cats in the Hamilton Range of Northern California. By helping to track and tag mountain lions, he was able to gain insight into the world of these elusive predators.

With his outdoor experience, love of art, meticulous attention to detail, and dedication to a thorough understanding of his subjects, Dave has secured a place for himself as a significant American artist.

Richard Sloan

was born in Chicago, Illinois. After attending the American Academy of Art, he worked as an advertising illustrator before joining Chicago's Lincoln Park Zoo as staff artist.

At first, his work was dominated by North American birds, but a 1969 trip to Guyana changed Sloan's life and art forever. Over the next four years, Sloan stopped painting North American wildlife and began specializing in jungle subjects. Annual visits have taken him to Mexico, Belize, Guatemala, Peru, Trinidad and Tobago to research his subjects in regions largely unvisited by tourists.

In 1994, Richard Sloan was named "Master Wildlife Artist" in conjunction with the Leigh Yawkey Woodson Art Museum's "Birds in Art" exhibition. Up to that point, his work had been exhibited in thirteen previous "Birds in Art" exhibitions as well as the museum's 1987 "Wildlife in Art" exhibit, and 1993 "Wildlife: The Artist's View" exhibit. Sloan is a member of the Society of Animal Artists receiving their 1990 Award of Excellence, the highest honor bestowed by the society. Sloan recently completed a series of forty-two paintings for the book *Raptors of Arizona*, published by the University of Arizona Press. Sloan's works are included in the permanent collections of the Smithsonian Institution, The Leigh Yawkey Woodson Art Museum, and the Illinois State Museum, and his paintings have been exhibited in some of the finest museums and galleries throughout the U.S. and the world.

Paco Young

is happiest when roaming the woods or fly-fishing a trout stream. His greatest artistic gift is to bring this love of nature to his canvas, to share it with the viewer.

Young had five years of formal training at the Memphis Academy of Arts, where he graduated with a Bachelor of Fine Arts degree. As with many contemporary schools, Memphis leaned toward the avant-garde, regarding realism as something not worth pursuing.

However, Paco Young had other ideas. He continued to paint wildlife in their natural habitat. Paco's paintings began to attract the attention of the art world as he traveled extensively to local and regional art shows.

In 1990, Young's artwork was selected by Leigh Yawkey Woodson Art Museum's "Wildlife: The Artists View," putting him in the national spotlight. In 1991 and 1992 he was named "Best of Show" by the Southern Maryland Wildlife Festival, and in 1994 he was named "Featured Artist" at the Southeastern Wildlife Exposition in Charleston, South Carolina.

Index